Watteau
The Great Draughtsmen

Watteau

René Huyghe

George Braziller New York

Watteau

Translated by Barbara Bray

General Editor
Henri Scrépel
Originally published in French under the title
l'Univers de Watteau, *in the series* Les Carnets de Dessins.

Copyright © 1968 by Henri Scrépel, Paris.

Published in the U.S.A. by George Braziller, Inc., 1970.

For information address the publisher:
George Braziller, Inc.
One Park Avenue
New York, N.Y. 10016

Library of Congress Catalog Card Number: 75-97899
Printed in France.

Contents

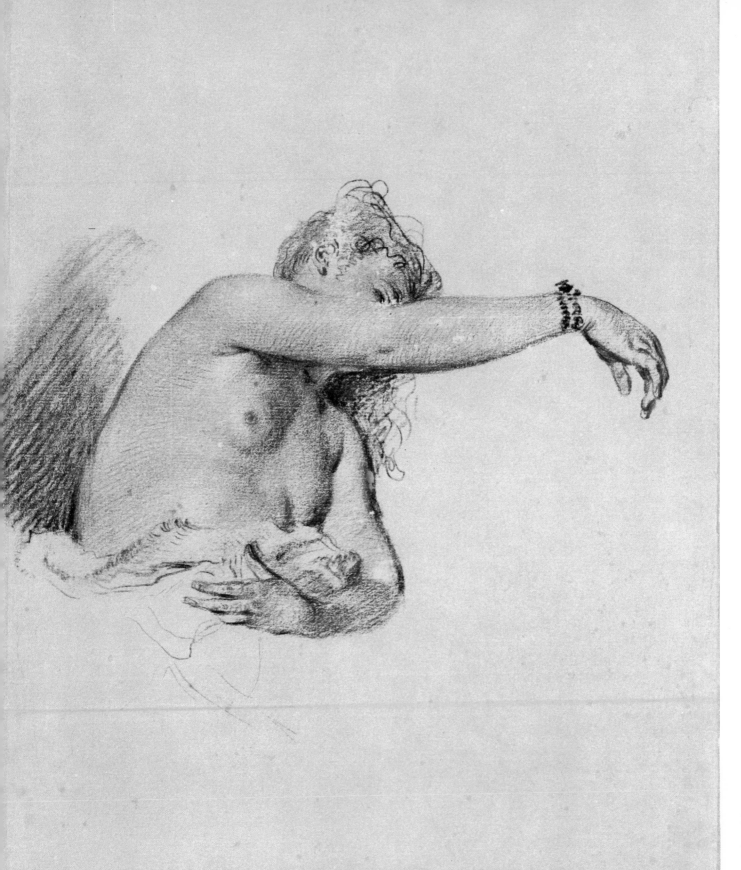

1.
Study of a nude
Red and black chalks

Louvre, Paris

Watteau

Preface

By a strange inevitability a work of art, often intended as no more than a faithful image of nature, strays from this exact reproduction in direct proportion to the genius of its creator. Undertaken to resemble reality, it comes to resemble the artist; it is born of the encounter and compromise between the two.

What is the true essence of an artist? Does it consist in his unique and individual character—the "originality" that both the nineteenth century and our own have insisted upon as the very condition of art? But how many external and fortuitous elements enter into the personality of an artist—his education, the influences he is exposed to, his observations, and above all the imperious and ubiquitous pressures of the age in which he lives? We seem to be faced by the alternative of trying to explain a painter entirely in terms of the outside forces that influence him, or of seeing him simply as an independent, autonomous individual bearing sole responsibility for his destiny and his work. We tend to yield to one extreme or the other of this twofold danger of interpretation.

In fact, although genius is not created by history it is dependent on it. History provides all those powerful forces from the past and present, whose components genius analyzes and forms into a whole. In ordinary people the total remains a mere conglomeration. Only the outstanding personalities, those who make rather than are made by history, form a new synthesis, a hitherto unknown, living, organic substance that seems an origin rather than a result.

Watteau is one of these outstanding personalities. He too, emerges from the nebula of his time, in which all the elements that contributed to his formation continue to intermingle. But he bursts forth from his background like a new star of unknown light and magnitude. The curious astronomer may perhaps discover in this nova the chemistry of its origin, but the new light and magnitude will henceforth remain distinctive and different from all the rest, never to be forgotten, however engrossing the study of the universe from which they sprang.

The "universe" of Watteau exists at the point of equilibrium between two opposing forces. One is the external pressure, the conditions of the age that always tend to constrain an artist. They surround and beset him on all sides, through what he sees and hears, and through all the hidden and subconscious relations that link every man to the society in which he lives. The second force is the inner drive of the artist as an individual, of his instincts and his temperament both physical and moral, and his unpredictable personal contribution. In proportion to its strength, this inner impulse tends to assert itself, to flow out into the world, and to adapt

and annex that world to itself. From earliest infancy the world exerts on this drive an exactly converse pressure that tries to force it into its own mold, harasses without respite, and is inherent in the very atmosphere the artist must breathe in order to live, and in all the accidents and encounters that make up a life. The artist succeeds only when he manages to find a balance between these two antagonistic forces, a line drawn by every work that issues from his mind and hands.

This balance is a living, shifting boundary. Although its general shape remains the same, unless some catastrophe occurs, it is continually questioned, sometimes at one specific point, sometimes over a long period. An unexpected element will arise suddenly in the outside pressure; the inner drive must parry in order not to be pushed back, and a new equilibrium is established. The inner drive, hesitant though eager for expansion in youth, also alters in the course of an artist's life: its power and abundance become increasingly controlled with maturity and sometimes even with old age, although more often the boundary then becomes rigid and inflexible.

Watteau unfortunately died too young to experience this ultimate adventure. But he felt with the peculiar force of genius, the urge toward the expansion of life—life that always yearns to extend its powers and strengthen its affirmation, and that always finds itself confronted by existence with all its limitations. The life that was the principle of his being, and the existence that was its history came together in his work, determining its character and its evolution. We must examine in turn that which Watteau received from the world into which he was born, that which he brought into it by his own genius, and the body of work that sprang from the conjunction. Then, even if we cannot completely elucidate Watteau's universe, at least we shall have found the paths that lead to it.

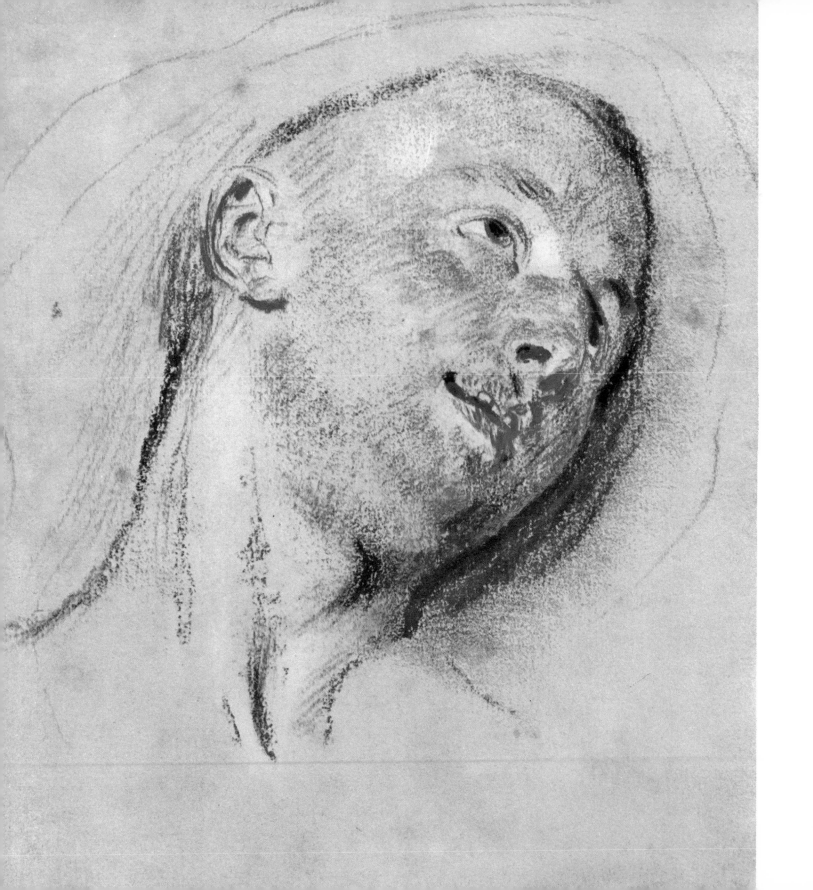

I

The Man and the Age

In order to be himself, Antoine Watteau, like every artist, had to be first a man of his time. The powerful molding he received from without was to determine some of his most important characteristics.

2. Study for "Le Mezzetin" Red and black chalks
Metropolitan Museum, New York

The Decline of a Great Reign

In the popular imagination Watteau is the incarnation of the eighteenth century: he ranks with Boucher, Fragonard, and Madame de Pompadour as one of the magic names that conjure up an age. And yet in the year 1721 when Watteau died at the age of thirty-seven, Boucher was only eighteen, Fragonard would not be born for another twelve years, and Madame de Pompadour was born that very year.

So Watteau—the living fount from which the entire eighteenth century drank the fresh waters of youth, feminity, and love that were repressed by Louis XIV and his austere Madame de Maintenon—lived most of his brief existence under the reign of the Sun King. He followed the king to the grave after only six years. The "Age of Louis XIV," which has been extended by official historiographers to accommodate Voltaire, did not, in fact, include Nicolas Poussin or Claude Lorrain, or Descartes or Pascal, all of whom belonged to the reign of Louis XIII. Likewise, paradoxically, Watteau lived more than five-sixths of his life under the king whose influence he did so much to abolish.

Watteau belonged to Louis XIV's decline, to the time when the ruler had outlived himself, his power, and his triumphs and found it difficult to suppress the lassitude and reaction born from his own absolutism. Watteau was a man of a new era, impatient for its arrival. It was not without a certain malicious pleasure that he gave his own interpretation to this situation when in 1721 he painted a signboard *(L'Enseigne de Gersaint)* for the shop "Au Grand Monarque", which his friend E.F. Gersaint had taken over from the art dealer Antoine Dieu. There, in the left foreground, the likeness of the "Grand Monarque" is already half buried in the straw-filled crate in which it will be taken away. The only farewell it receives are the indifferent glances of the none too eager porter, the harassed workmen, and the pretty young woman being guided into the shop by an attentive gentleman of the Regency. *Sic transit...*

Watteau owed the old king even less loyalty than other young men of the rising generation. He was barely one of his subjects, for the Flemish town Valenciennes, where he was born in 1684, had become part of France only under the Treaty of Nijmegen in 1678. The culture and language of Hainaut had, of course, long been French, but the province could not be expected to feel any affection for a monarchy not its own that had inflicted on it the ravages of war. Nor was it likely that Watteau, when he went to Paris in 1702 to seek his fortune, "penniless and with only the clothes on his back," should immediately go over to the enemy camp. The old king was not popular: a few years later his funeral procession would have to rush along a winding route through the city to Saint-Denis to avoid the jubilant drinkers celebrating in the streets. Moreover, Watteau, after a short period of copying paintings by Gérard Dow for a slave driver on the Pont-Neuf, became pupil and assistant to Claude Gillot. No teaching could have been more hostile to the art of the Grand Siècle

and to such men as Charles Le Brun and Pierre Mignard. Gillot, who had only contempt for their pomp and artifice, had long been an admirer of the Italian Comedy and its mordant wit. But mordant wit is rarely on the side of the powers that be, and the commedia dell'arte carried theirs so far that in 1697 they were banished from France. The standards Gillot used for his figures had nothing in common with those of the Royal French Academy. His were fine, slight, and mannered: much closer, in fact, to those of Francesco Primaticcio and the School of Fontainebleau.

Thus, Gillot's work is one example among a hundred of the eighteenth century's opposition to Louis XIV by its renewal of ties with a freer time before his reign. In many respects the new era seemed to resume interrupted currents from the sixteenth or early seventeenth centuries. Gillot was one of the most active proponents of this revival: indeed, people are often tempted to see him as a successor to Jacques Callot, in whose work the Italian Comedy had also been a frequent theme. But the Italian Comedy really belongs to the sixteenth century that gave it birth. Pantaloon, Harlequin, and Isabella are represented in many pictures dating from the time of the Valois, and the great number of copies indicates their popularity.

The novelty that brought success to Claude Audran—curator of the Luxembourg Palace and the second of Watteau's Paris employers, for whom he went to work in about 1707—also had its origins in the sixteenth century. It was then that the School of Fontainebleau affirmed the preeminence of Woman, a concept which was to be repudiated by the virile aspirations of Louis XIV's *Grand Règne* but would again triumph with the new century. Audran was also an underminer of official tradition. He worked as a decorator, not of vast palaces with spectacular expanses of surface, but of the interior paneling with which it was becoming fashionable to adorn town houses. He thus contributed to the denial of the grand, academic style and to the development of intimate, luxurious interiors, through which "society" was coming to replace the court.

Where did Audran find the model for his slender, airy decors, for the free meanderings in which Gillot had also indulged? He found it even farther back than Jean Berain, the reviver of the "grotesque": in the sixteenth century, at Fontainebleau, where he traveled to study the work of Primaticcio. Nor should we forget that Charles de la Fosse, who was to play so important a part in Watteau's development, was always glad to make a similar pilgrimage, and that Pierre Crozat, whose collection Watteau knew, included no fewer than four hundred drawings by Primaticcio.

Majesty and solemnity were now things of the past. The weighty ostentation and authoritarian symmetry of Versailles disappeared with the athletic masculine forms of Le Brun. The fullness of the solar circle yielded to the feminine and subtle oval.

When, in these new surroundings, Audran depicted dallying lovers instead of gods and heroes, it was only the conclusion of a tendency beginning in the sixteenth century. Then, everything had been related to Woman—there was no beauty but in her shape, no seduction but in her grace, and no taste but what took its measure from her delicacy. It is in the sixteenth century that we find the predecessors of those *nus galants* and *dames à la toilette* that tempted Watteau sometimes and his successors often.

The tradition of feminine or amorous themes really goes back to the Middle Ages, to the thirteenth century and its discovery of courtly love, which the fifteenth century was to cloak with naturalism. France has always lived with an agelong alternation between her virile and feminine, warlike and urbane qualities: an alternation that allows her to renew herself continually without self-contradiction. The court of the Valois both echoed the courts of love and foreshadowed the alcoves of Madame de Rambouillet and the *Précieuses;* the art of amorous exchanges became the raison d'être of the social life that France alone can elevate—or reduce—to the life of society itself. The universe of Watteau is nowhere more accurately prefigured than in the *Heptameron* of Marguerite of Navarre or the *Astrée* of Honoré d'Urfé. The lovers of d'Urfé, Gombaud and Madame de Scudéry, like those of Watteau, all dream of escaping everyday life to become gentle shepherds worthy of the solitudes of the *Pays du Tendre.* And the inaccessible island inhabited by Alcidiane in Gomberville's *Polexandre* (1632) is surely the same that Watteau was to call first the *Ile enchantée* and then the *Ile de Cythère.*

The "gallantry" celebrated by the sixteenth century and codified under Louis XIII was quickly eclipsed and vilified by official, classical literature. But it would be a mistake to suppose that novels, though overshadowed, disappeared: they continued to enjoy a considerable though discreet popularity. They no longer belonged to the court: under the inescapable laws of imitation they descended to the bourgeois society of the Marais and the Place Royale which prided itself on imitating the fine manners it read about. Although the novel was ignored by the court, occupied with newer fashions, it resumed its former influence as the prestige of the court declined and the power of the town increased.

The apparently fantastic dress of Watteau's lovers is really "local color" and reveals the heroes' origin. It is the dress of the age of Louis XIII, of Rubens' noblemen in the *Life of Marie de' Medici* which Watteau admired in the Luxembourg Palace, of Van Eyck's subjects, contemporary with the heroes of Honoré d'Urfé, and with the last splendors of the Luxembourg Palace. The clothing is neither novel nor daring but simply archaic; however, like the theater, it helped Watteau arrive at the world of the imagination.

Watteau lived, then, in an atmosphere strongly influenced by the early part of the previous century. He never forgot the ringed columns of Salomon de Brosse's architecture which can be found in *Les Plaisirs du Bal* (The Pleasures of the Dance) and *Les Charmes de la vie* (The Charms of Living). They probably merged in his memory with the architectural forms of Rubens (which perhaps had also been inspired by the Luxembourg Palace, where Rubens had painted the sumptuous apologia for Marie de' Medici less than a century before Watteau came to admire it).

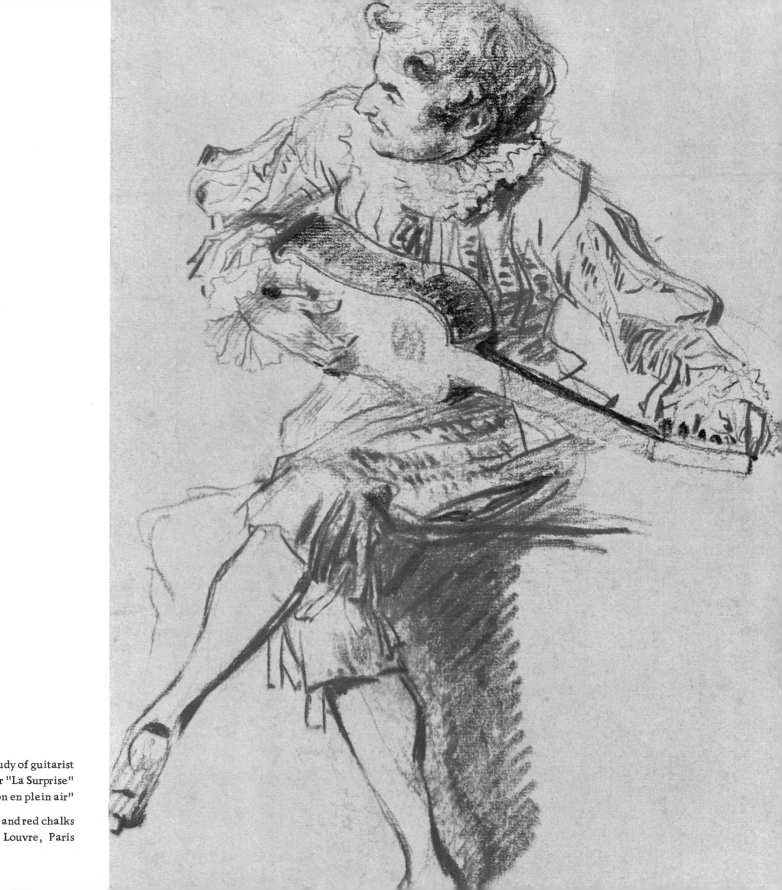

3. Study of guitarist
for "La Surprise"
and "La Réunion en plein air"

Black and red chalks
Louvre, Paris

The Impetus of the Baroque

During his stay at the Luxembourg Palace, what impressed Watteau even more than the richly wooded gardens of Louis XIII (where reason had not yet come between man and the flow of nature) was Rubens *(Fig. 38)*. The entire place was imbued with his presence and works. Watteau was born and raised as a Northerner, and he felt close to Rubens despite the great temperamental difference between them.

For some years Rubens had been the symbol and rallying point of reaction against the official art of Louis XIV. The quarrel between the Poussinists and the Rubenists had just ended with the victory of the latter. So Watteau, already predisposed to innovation, was brought by chance to worship at the same shrine as the rest of the younger generation.

Rubens or Poussin? Flanders or Italy? The new century had made its choice. Halfway between the two poles of Europe, the North and the Mediterranean, France has always drunk from both sources, sometimes divided between them but in the end, always enriched and diversified by their meeting. One has reinforced her sense of reality, her physical contact with things: the other has elevated her to the order and harmony of reason. Absolute power has always instinctively favored the logical, stable, and symmetrical structure of classical culture, and this was especially true of the reign of Louis XIV. Now man's spirit longed for the fresh water of the sensible world, where Rubens offered a rushing torrent.

France was not denying her character but recognizing the need to change the proportion among the elements which made up her traditional equilibrium. She was about to revive all that could help preserve her from the desiccation that suddenly threatened. She sought support from within and without, renewing contact with eras thought to be surpassed, and reversing her artistic allegiance toward the North. This reorientation in time and space brought her into contact with the baroque, which classicism had rejected. Not that France planned to overthrow the established order: her object was to moderate, humanize, and expand it. She did not repudiate classicism but made it adapt to all that absolute purism had rejected. Architecture remained faithful to the grand style and its colonnades, but furniture yielded to the intoxicating curves of Meissonnier and Oppenord; although Nicolas de Largillière's sitters still wore wigs, they were wigs that he had learned to paint in Antwerp. The same was true of Watteau's masters. Audran made use of grotesques of the Italian Renaissance and of Raphael, but he gave them new freedom with the light and sinuous forms of Fontainebleau Mannerists. La Fosse, who would become Watteau's patron during his early successes at the Academy and his first association with Crozat, was a student of Italian art, whose taste led him to the Venetians, Titian and Veronese, the most powerful counterbalance to Italy's own nascent academicism.

Watteau's drawings faithfully reflect the lessons he was taught. He avoided full, expressive curves and volumes and, like Gillot, preferred vigorous scribbles and a sharp, straight, sometimes abrupt line. These are two basic characteristics of drawing in the North. But the baroque also tempted him, and he added its swift, irregular sinuosity, curly accents, and curvilinear preciosity to the fine proportions and sharp points of mannerism. The same notation was used by Gillot, especially in his foliage and his designs for ornament and doors, and it was even more marked in Audran. This style evokes once again the period before Louis XIV. Watteau, who at the time was a great frequenter of printshops, may have come across some engravings or drawings by, for example, Jacques Bellange. He would have recognized a forerunner in Bellange's group of elegant young women conversing in their long, stiffly folded gowns, and in the series *Les Cinq Sens* (The Five Senses), in which a girl bows her head over her lute while one of her companions smells the perfume of a rose. And are not Watteau's hands, restless and disturbing, nervous to the point of morbidity *(Fig. 40)*, foreshadowed in the thin, supple, searching hands drawn by Bellange?

Watteau, then, echoed the early eighteenth century's desire to renew its sources. But he gave his age as much as he received. Although antecedents can be found for his work, none of them reaches its fulfillment. Such is the role of genius: to come into a world confusedly filled with jostling, indistinct aspirations, and to give life, shape, and meaning to these scattered potentialities. We may try to explain Watteau in terms of his age, but it is really he who defines it. From his time he received the molten matter, but he alone gave it everlasting form, repaying his debt a hundredfold and conferring on the eighteenth century the best of its significance and unity.

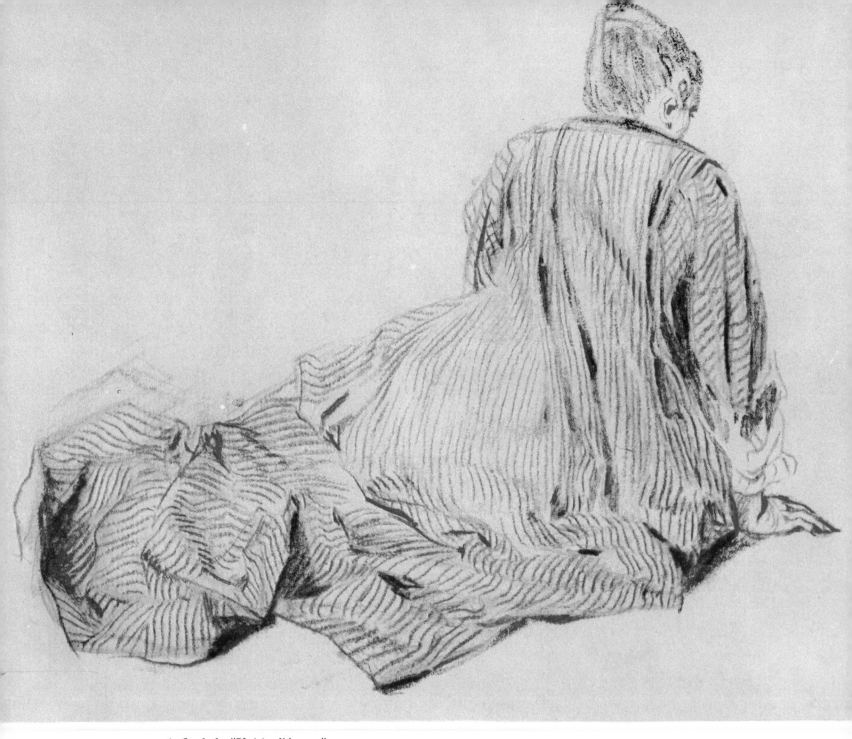

4. Study for "Plaisirs d'Amour"
 Lead pencil, black and red chalks

 British Museum, London

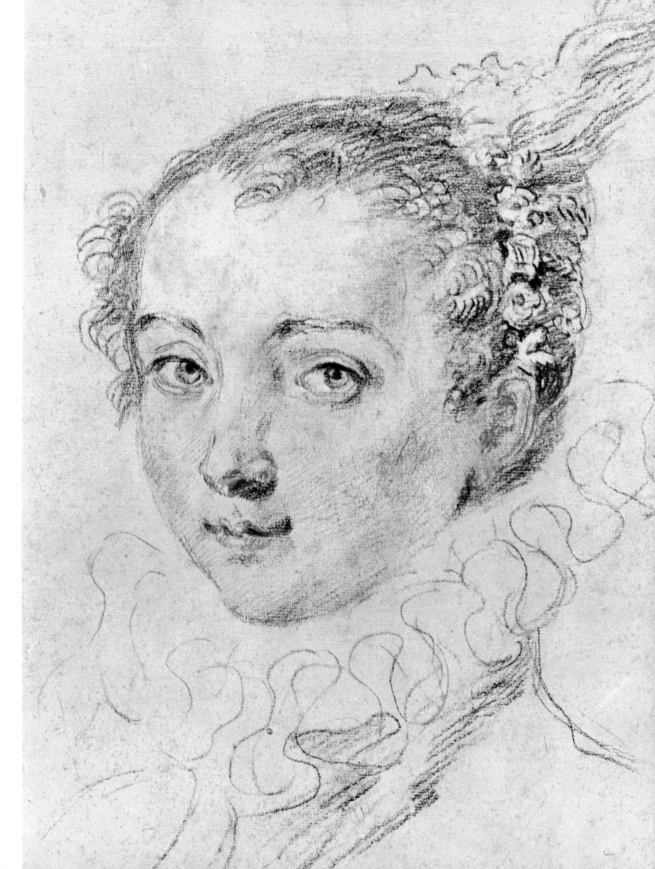

5. Portrait of a girl
Black and red chalks

Boymans Museum, Rotterdam

Northern Realism

Watteau fitted in easily with his times because of his Northern spirit, which was especially welcome during a period when Italianism had reached the saturation point.

Among the subjects he had treated or would treat, there were few that had not already been painted by Northern artists. His master, Claude Gillot, had borrowed his Italian players from sixteenth century tradition, but Northern hands had painted them. There was a certain triviality about them that could not have pleased those who went to Italy in search of a nobler inspiration. It is symptomatic that while Watteau took over the Italian comedians from Gillot, he was careful—for the moment—not to adopt his classical subjects, such as the Bacchanalia.

But what about the shepherds and shepherdesses? Watteau followed his master's example here: the main group in his *Colin-Maillard* (Blind Man's Bluff) is taken from a drawing by Gillot now preserved in the Louvre. But even here Watteau remained faithful to the Northern tradition of Adriaen van Ostade and Teniers the Younger : in early works such as in the *Vraie Gaieté* (True Enjoyment) he saw only rural games and the *Danse Champêtre* (Rustic Dance), shepherd's pipes. Even in the *Repas de Campagne* (Country Repast), which had something of the brothers Le Nain, Watteau still did not emerge from rural realism.

One might presume that the tradition of *sujets galants*, which Watteau encountered in the work of Audran, had nothing to do with the Northern school. But if the spirit of such work originated with the School of Fontainebleau, the theme itself did not constitute a break with the Northern heritage. At the beginning of the seventeenth century the School of Utrecht had followed Caravaggio in depicting amorous episodes in which hearty, rustic lovers embraced their mistresses to the sound of the guitar. But the subject soon grew more refined and rose from the already quieter guardrooms of Pieter Codde and Jacob Duck to the fashionable world of the School of Delft, where elegant young men and women conversing or making music moved in an atmosphere of poetic languor. All this Watteau would transpose from the real world of experience into the fairy realm of sensibility.

In the north Watteau found even more clearly the predecessors of the military scenes that he painted during a visit to his native Valenciennes; these were exceptional only in French painting, where they introduced an entirely new note. Even in the seventeenth century, the Dutch had seen war from the same immediate point of view: many pictures show camp life in its less heroic moments with soldiers smoking, cooking, and not neglecting to pay proper attention to the girls.

But Watteau's Northern atavism revealed itself in deeper and less episodic ways. He hated intellectual convention, even when it was upheld by the sanction and effort of centuries. History and fable left him

unmoved, as did myth with all its supporting rules. He loved what was true and real, inasmuch as it could be the starting point for passionate reverie. Nature for him was, if not art, at least its essential point of departure, a recourse against traditions and habits that, however noble, end by mechanizing man and making him sterile. He always said to his pupils, such as Nicolas Lancret, that he could not waste his time any longer with a master, that he must carry his experiments much farther under the master of masters, Nature, which was what he had done before and with which he had been well satisfied. In our time, realism that has become routine and opposed to creativity is condemned. But, at that time, realism alone made creativity possible because it freed artists from the Academy and the imitation of the masters. The realists had to get rid of the Carracci and Le Brun, Italian seventeenth century formulas, and traditional methods.

As soon as Watteau felt the influence of Gillot or Audran becoming too strong, and suspected in himself the beginning of a "manner," he escaped and sought refuge in Nature: he went back to Valenciennes and made many direct studies of realistic scenes. But Nature was in him as well as around him. Like all Northerners, he could look at it eagerly and also let it speak to the depths of his being. He knew Nature's inward face, which is Life, the sincerity of feelings as well as of sensations, and which can never be replaced by an idea. His starting point was both Nature in general and his own nature. He differed from Rubens only in so far as their temperaments differed; in both, the initial creative mechanism was the same.

Watteau realized and accepted the fact that he was a Northerner. When he arrived in Paris, he began by making quick copies of Dutch and Flemish paintings in exchange for room and board: for example, Gérard Dow's *Saint Nicholas* and *Old Woman*. He soon found himself at home with the group of Flemish artists that congregated about Saint-Germain-des-Prés, free-lance artists rebelling against official art. At the " Maison de la Chasse, " which still stands at the corner of the rue du Dragon and the rue du Four, the young man from Valenciennes met both compatriots and new friends—the Spoëdes, the Wleughelses. It was quite close to the old church of Saint-Germain, where the painters' guild used to meet in one of the chapels. The Le Nains were hardly farther away: they lived first in the rue Princesse, then in the rue du Colombier, afterwards in the rue Jacob. Jean-Baptiste Chardin would not be far off either: he lived all his life in two houses in the rue Princesse. So Watteau lived in a neighborhood that was a kind of foreign outpost of Northern realism, where the Foire Saint-Germain exhibited "Flemish works. "

The line that runs from Le Nain through Watteau to Chardin is of Northern rather than Italian derivation. All three artists shared a special technique in which the paint on the canvas consists of pure colors blended, almost knitted together, to create a tone that appears neutral but is full of almost imperceptible richness.

All three reacted to everyday life with a realism penetrated by feeling: what could be closer to Chardin and his studies of familiar objects than Watteau's *L'Occupation selon l'âge* (Different Ages and their Occupations)?

If Watteau left the neighborhood of Saint-Germain, he went to rue Saint-Jacques to look at the collections of print dealers he knew, in particular, the Mariettes. It was probably there that he saw all of Callot. Madame Hélène Adhemar has pursued this line of inquiry in a masterly fashion, and has shown how much Watteau owed also to more recent artists like Bernard Picart and Claude Simpol (*Watteau. Sa vie, son œuvre*, Paris, 1950). In an article she has pointed out how these engravers, whose *sujets galants* inspired Watteau, sometimes executed scenes of popular life as well. Simpol's *L'Oublieuse* (Forgetfulness) and *La Ravaudeuse* (Woman Darning), she writes, "are closely linked to the tradition of Le Nain." These prints were directed toward a general audience whose tastes were different from those of the court. Thus, popular elements that were forbidden elsewhere could be retained. Here, once again, Watteau found an age and a school which had lost the favor of official art: the age of Louis XIII and the Northern school.

It was now safe for him to set out in search of himself, for his native country. He knew what he would find along the way: beggars and soldiers whose daily life was on the road more than in the battlefield. In order to get money for the trip, he gave the dealer Sirois a picture done from his imagination and without Audran's knowledge. For its subject, Watteau ignored all he had learned from his masters and chose the *Départ de recrues* (Departure of Troops), showing the infantrymen in uniform and laden with heavy packs.

What he saw was *La Halte* (The Halt), *Le Bivouac* (The Encampment): camp life with its inglorious train of battered followers, improvised cradles, and field kitchens. The epic was over and, in the muddy plains of the North, disaster was approaching like the gust of wind that, in *Les Fatigues de la guerre* (The Fatigues of War), twists the trees and makes the wet coats flap. A presentiment of the humiliating campaigns at the end of the *Grand Règne* could already be found in Sebastien Bourdon's *Halte de soldats et de bohémiens* (Halt with Soldiers and Gypsies) and *Corps de garde*, in similar works by Mathieu Le Nain and Jean Michelin, and in many of Callot's engravings. Watteau carried on where they left off. It was as if the great pageantry of Louis XIV had never existed. As if he wanted to exhibit the source of his realism, Watteau did not refrain from the traditional triviality of Flemish painting, foreign as it was to his temperament. These unheroic scenes show the cauldrons simmering, the sons of Mars more inclined to take a nap than an offensive, and the daughters of Cythera more used to patching and darning, and swaddling babies, than to exercising the wiles of seduction. Watteau included earthy details, so characteristic of Flemish painting. Sometimes a soldier is shown obeying a call of nature; one, in *L'Escorte d'équipages* (The Baggage Escort), has stepped aside to let down his trousers. At the theater, which later was to lend him such shimmering harmonies, Watteau particularly noticed a scene in which an enema is administered to Molière's Monsieur de Pourceaugnac.

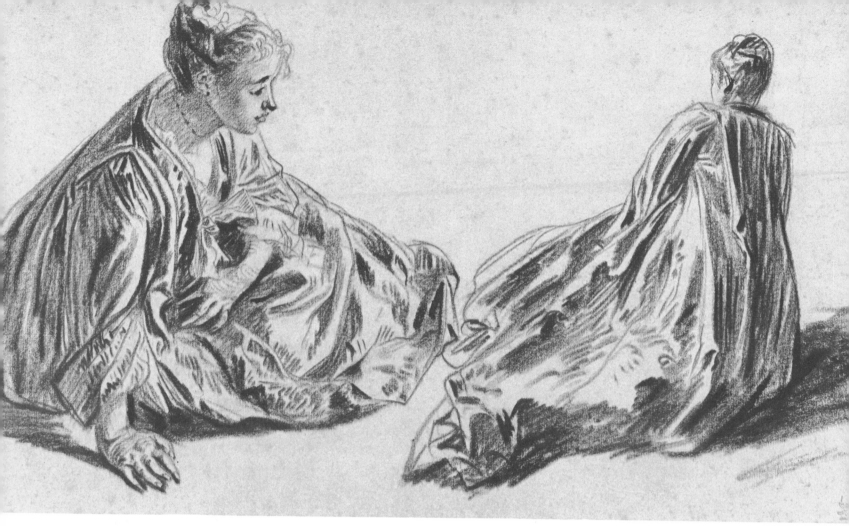

6. Study for "La Game d'Amour" Red chalk

Rijksmuseum, Amsterdam

When he turned away from the war, he made studies of the tramps and vagabonds and all the tattered ill-shod crew that passed up and down the highways: chimney sweeps, peddlers, pilgrims, knife grinders, who all carried their scrips or means of livelihood with them in heavy boxes. At this point, reference to the brothers Le Nain is not presumptuous. Here, their spirit lives again just as their characters do in some of Watteau's military scenes. The group of peasant women seated around a cradle in *L'Escorte d'équipages* brings them to mind immediately. This is no false trail; a page of sketches shows that the heads were copied literally from the master of Laon and, in particular, from his *Retour de Baptême* (After the Christening).

The Classical Tradition

Through his origins, his first masters, the milieu in which he lived, and the examples he encountered, Watteau eluded the official art of the seventeenth century. He disliked it and, to some extent, was ignorant of it. All his instincts and upbringing predisposed him to turn away from it.

But he was not one to have a single, oversimplified reaction. He was too great not to feel the richness of tradition in which the academic was only barren decay. He spurned tradition in this form, but welcomed it when he could supplement his own gifts. (In 1709, before he left for Valenciennes, he became a candidate for the Prix de Rome and, in 1712, his perseverance won him the unexpected honor of being made an associate member in the Academy.) Rubens had developed Northern painting to the heights he did by realizing how much he could learn from the Renaissance. Although Watteau rejected the manners and conventions and steeped himself once more in his native realism, he also wanted to penetrate the mystery of classical Italy, the origin of style. He was a born enemy of Le Brun, but much nearer to Poussin than is usually supposed.

He refused to turn to an idea or example for inspiration, as history painters did. For him, the only point of departure for a work of art was the acute sensation or emotion of contemplating Nature. But he allowed the mind, with its faculties for ordering and composing, to complete the work. If we exclude Le Brun's sectarian and distorted account of great French classical painters, we find that the genius of Poussin and Claude resides in these same qualities of poetry and organization. They knew how to achieve the plastic unity of a painting through noble rhythms but they also discovered the power of deep feeling that comes from life. Claude had already made his pictures open out to the distant and infinite and their mirages, which gave them an unlimited resonance and dreamlike power. However, Poussin and Claude belong to the period before Louis XIV, to which Watteau always turned. He was its fulfilment: he sent the roots of his art down into the healthy soil of reality (like Louis Le Nain), and he let its stem soar up into the regions of sensibility and dream to which Claude had pointed the way. Like Poussin and Claude, he knew that an artist must attain that ultimate fusion of emotion and reflection which is called style. That is why, like Rubens from Flanders, like Poussin from Normandy, and like Claude from Lorraine, Watteau wanted to enrich, but not deny, his own art through learning about the culture of the Mediterranean. If fate had not prevented him, he would have gone to Rome as these artists had. But receiving second prize in 1709 and being made a full associate member of the Academy in 1712 ruled out a trip to Rome.

It seemed as if Watteau would not get his classical accolade. To make up for it, he seized the opportunity, probably given him by La Fosse, to study in Crozat's collections. In Crozat's house in the rue Richelieu he had ample time to admire, study, and copy his host's accumulated treasures. We know that not long afterwards he actually went to live with Crozat, as La Fosse already had, and was thus installed within arm's length of portfolios crammed with the finest drawings. (After Crozat's visit to Italy in 1715, the Italian School

was particularly well represented). Watteau now reached the culminating point of his education, especially as a draftsman. In 1709, during the trip back to his sources, Watteau had found in Nature what would protect him from the "manner." Now he turned in the opposite direction, to qualities his origins could not offer, toward what would open the way to style.

In Crozat's collection he could rediscover and again enjoy Rubens. However, it was the Italians that now attracted his attention since they brought the revelation for which he had been waiting. Instinctively, like La Fosse and the Regency, he turned toward those artists in whom the classical spirit was tempered by a sensibility akin to that of the North: the Venetians, whom nature had placed at the crossroads of Italy, between the East and the North. For the Northern painters the Venetian school served as just the transition they needed into an art otherwise too different from theirs. Rubens, Van Dyck, and Poussin had had recourse to this school, and the French Rubenists had found it closer to their Flemish idol than the thoughtful rigor of Florence or Rome. They considered themselves kin to the Venetian school, La Fosse most of all. In his turn, Watteau steeped himself in Titian, Domenico Campagnola, and Veronese. From one of Veronese's drawings which later passed from Crozat's collection into the Louvre, Watteau derived his painting of *Vénus désarmant l'Amour* (Venus disarming Love). He borrowed from Veronese the idea of the little Negro cupbearer in *Les Plaisirs du Bal* and *Les Charmes de la vie (Fig. 51)*.

Then and only then did he complete the formation of his art. Gillot and the North had bequeathed him the power of incisive imitation. Audran had helped him understand line, its refinement and elegance, and the ornamental resources of curves. Now the majestic voice of the classical masters taught him that these two powers, the imitative and the decorative, though in apparent opposition, could be made to reinforce each other. By asserting its continuity, line brought out the essence of form which, concentrated and considered, gave harmony. Watteau was no longer forced to choose between truth and elegance, realism and refinement: both came to fruition in uniting. And this union, characteristic of the Italian genius, became, in the hands of the Venetians, the instrument of the soul in search of self-expression.

From now on, Watteau had full control of his means. His draftsmanship, more accurate than ever, joined quite naturally with a formal breadth of line. The universe of Watteau could now come into existence: bringing together exactness, idealization, and suggestion. His brush could combine the heritages of Venice and Rubens by making use of pigment to define the forms and the glaze in order to add all those nuances of light with which modern painting begins.

From the heritage of the past and the teaching of the present, Watteau had learned all he could hope to learn. From this he now had to draw meaning, and communicate to others what was his alone: the essence of his own sensibility.

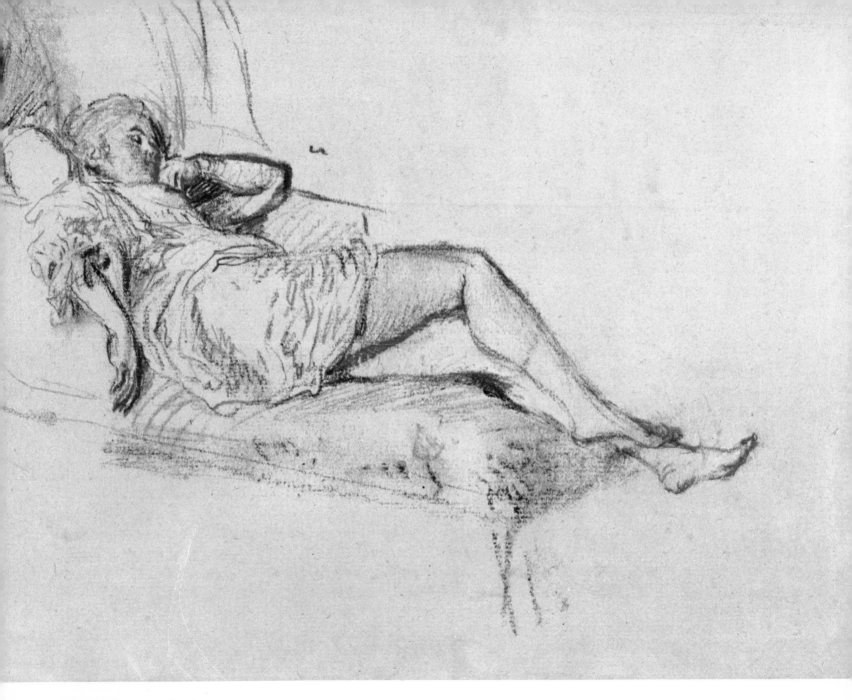

7. Study of a woman sleeping
 Black, red and white chalks

 Private collection

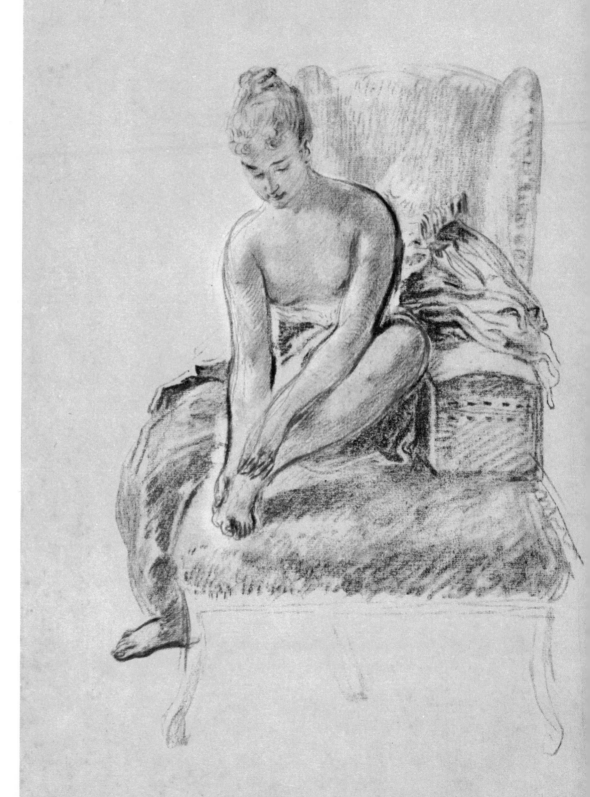

8. Study of a woman at her toilette
Red and black chalks

British Museum, London

A Confidential Art

Although Watteau translated into his own terms all that he borrowed from his age, this does not mean that he escaped from it: he still obeyed its laws. This very ability to assimilate all the elements drawn from his time and to use them in expressing himself and his hopes is, indeed, the sign of a new era. This was the time of individualism, of art as one human being's confession of what distinguishes him from all others and makes him unique. No one before him, except perhaps El Greco or Rembrandt, had so openly pursued in painting the image of an individual dream. Another century would have to elapse before romanticism recognized him as a great precursor, and accorded him his rightful place as a forerunner of the modern sensibility.

Though for some time there has been a great reaction against the individualism of the nineteenth century, we are still too deeply imbued in its concepts to be able to fully assess Watteau's contribution. We take it for granted that art should be connected with the idea of spiritual confidences. In doing so, we forget that for centuries, even millennia, art was, above all, a sociological instrument, limiting itself to the task of translating into images the myths and dogmas of the community or of furnishing its setting with certain established amenities. Society expected the artist only to exercise the talent of realization and if he added his personal imprint, he did so unconsciously. Themes, formal rules, and methods of execution were established and imposed by the needs and traditions of society. There was no question of interpretation: the painter's only task was to transcribe. All his age expected of him was skill, and the originality that we have made the supreme criterion of artistic worth was regarded as meaningless and eccentric. However, it was out of the need for quality, the only sphere left to individual judgment, that there gradually emerged interpretation, transformation, invention, and, finally, re-creation conforming only to inner laws. In the end, art became the ideal expression of personality. The West had a long way to travel from the Middle Ages, when the artist was an instrument and a scribe making pictures dictated by society, to modern art, where no artist considers himself worthy of his calling unless he opposes and undermines the general view of things. Watteau made a powerful contribution to the transformation of art into an escape, the materialization of a "private" dream, instead of an echo of collective truths. His vision exercised such an influence over his successors and inspired so many imitators that it has come to embody the whole age, almost the whole century, to which it belonged. But we must not forget that while it fulfilled a contemporary need, it was also fundamentally new and creative.

Watteau's task was probably made easier by his age's reaction against the Grand Siècle. Then the strict discipline of the State clamped down on the individual, who had been prematurely emancipated during the period between Protestantism and the Fronde. The breakup of religious unity and the exaltation of humanism, both confirmed by the Renaissance, may well have liberated genius and prepared the way for Watteau's independence. But even the boldest of those before him who had created a personal universe—Michelangelo,

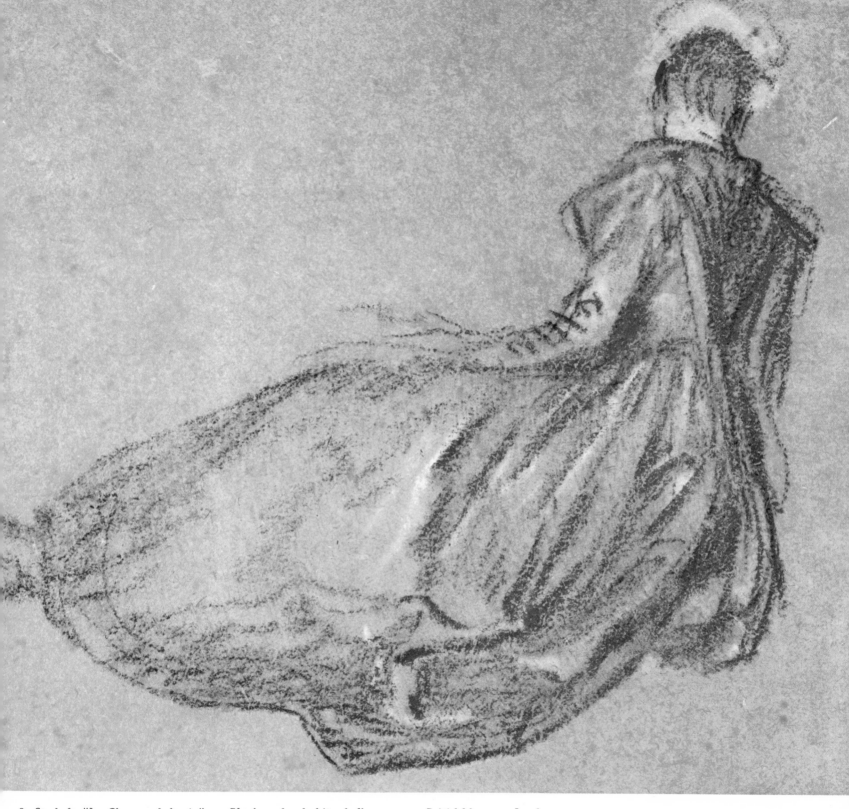

9. Study for "Les Charmes de la vie" Black, red and white chalks British Museum, London

29

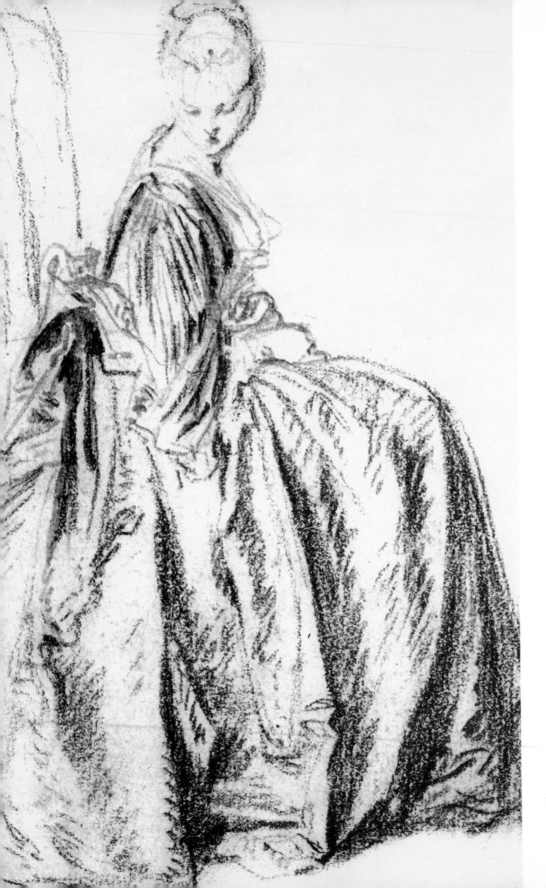

10. Study of a seated woman
 Lead pencil and black chalk

British Museum, London

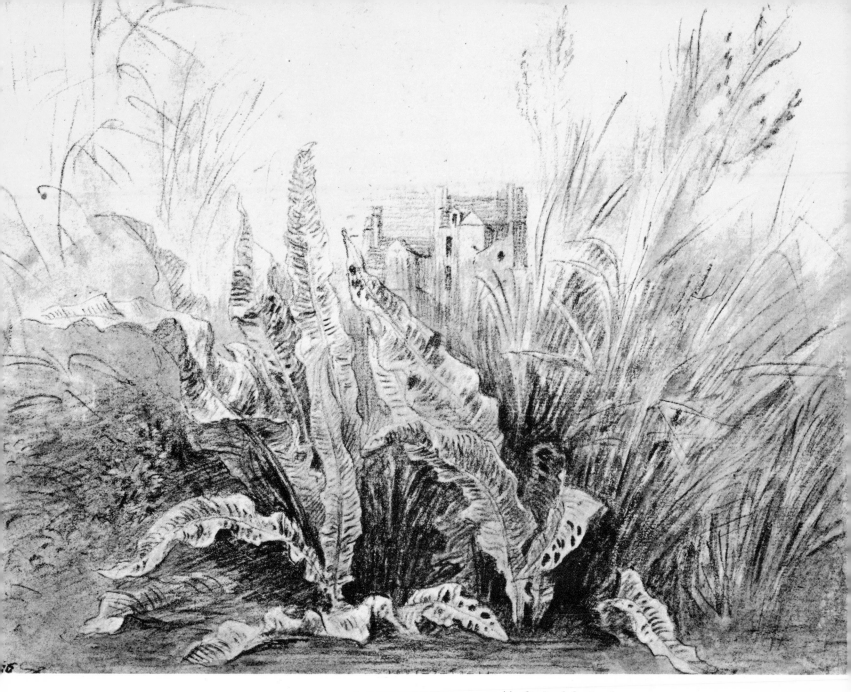

11. Study of plant and grasses
 Black chalk and wash in Indian ink

 British Museum, London

31

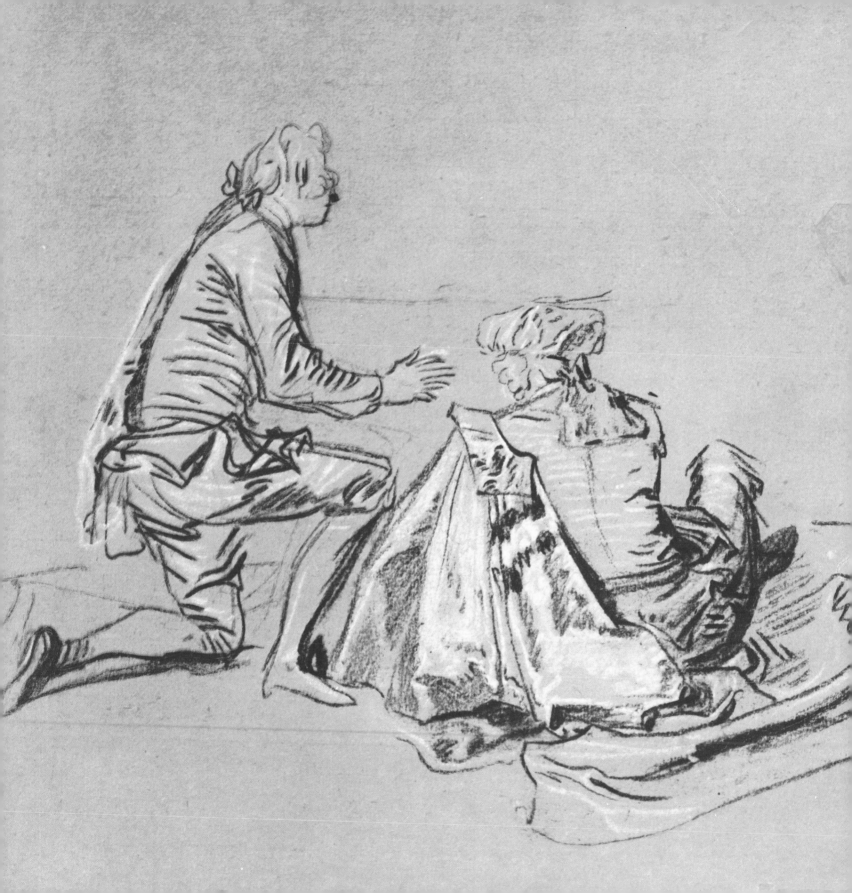

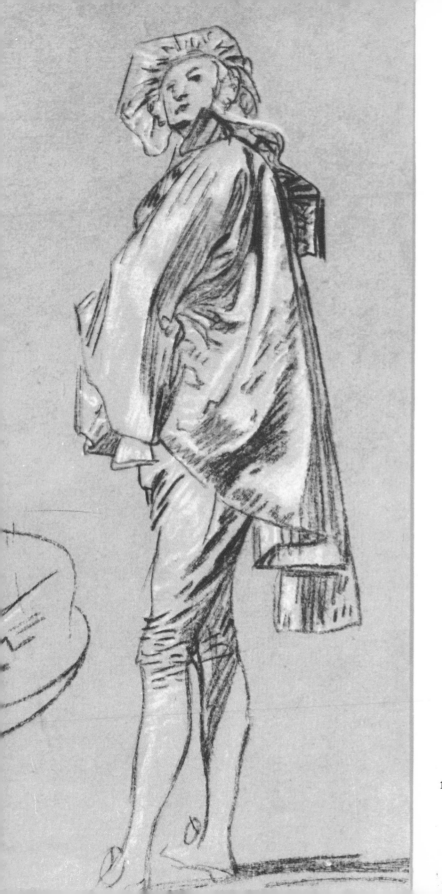

12. Studies of a dancer for "L'Ile enchantée"
and "Les Plaisirs du Bal"

Red and white chalks
Louvre, Paris

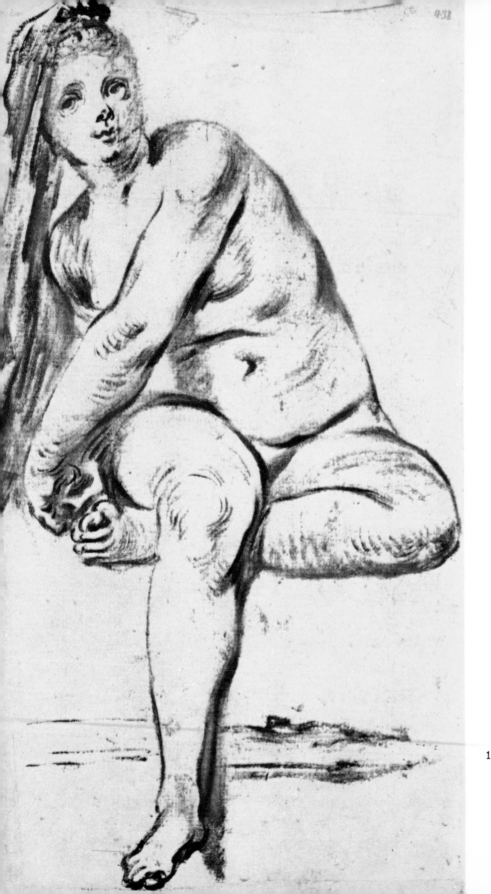

13. Study of a nymph
 for "Le Bosquet de Bacchus",
 "La Leçon d'Amour",
 and "Divertissements champêtres"

 Brush sketch
 Private collection

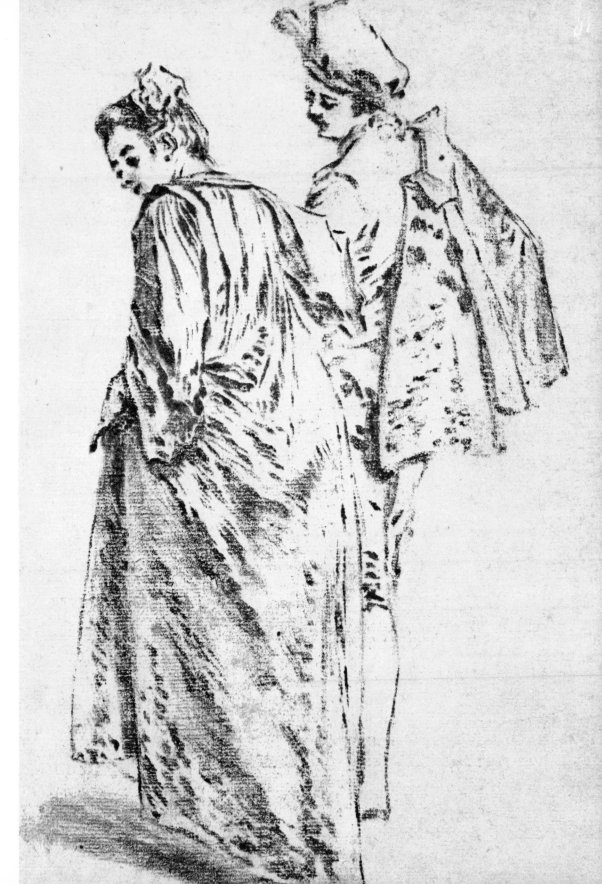

14. Study for "L'Amour paisible"
Brush sketch

British Museum, London

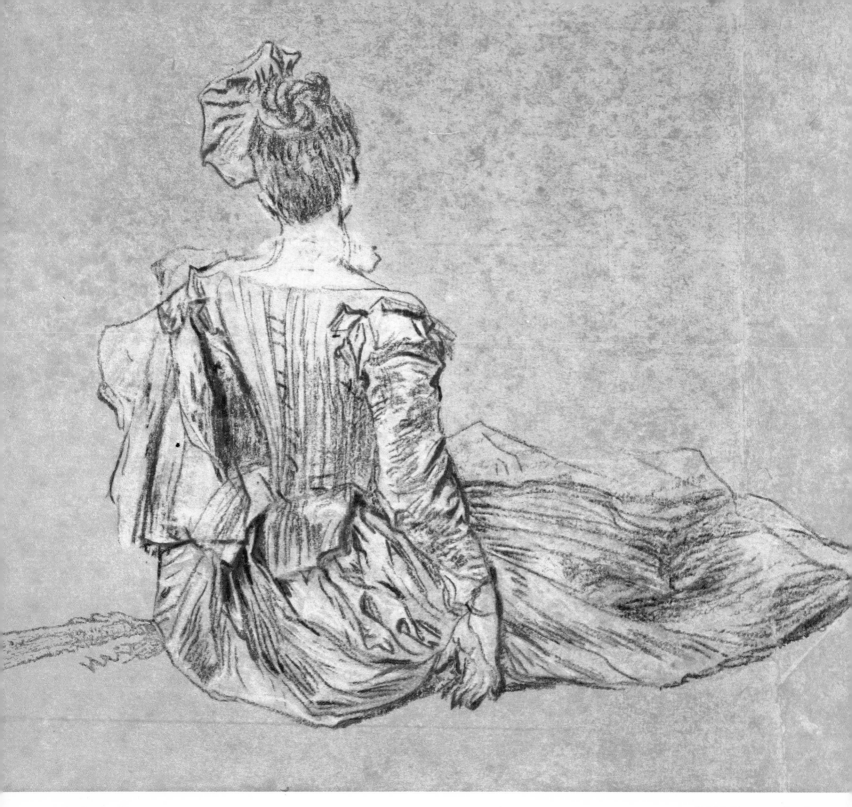

15. Study of a seated woman
Black, red and white chalks

British Museum, London

Tintoretto, El Greco, Rembrandt—assumed only the freedom of interpreting the great collective themes which had been handled and polished for generations. This freedom scarcely exceeded that of an actor interpreting a role: the painter's imagination could only throw a differently colored light on an already established iconography. Michelangelo himself, like a great tempest that can only fill the sails of the ship on which it blows, could not go beyond the Old Testament, though he stretched it to its limits. Even the greatest innovators and inventors of images, like Albrecht Altdorfer, and Tintoretto, could do no more than reconsider and rework episodes from religious or secular history. El Greco himself could only transform their appearance into apparition.

In the seventeenth century a hidden evolution took place. A few great artists no longer used their invention just to serve religious subjects. Instead, they used the subjects as a pretext for the expression of ways of being or feeling. They selected themes best suited to their temperaments: Rembrandt to his mystery and Rubens to his vital force. Those artists who, like Ruysdael and Vermeer, went so far as to escape from pagan myth and Christian religion altogether and observed reality instead, confined themselves to imparting a personal accent to scenes whose accuracy everybody could check. True, Poussin, with his theory of modes, caught a glimpse of the possibilities for an artist to express inner or spiritual states by his choice or presentation of subjects. But this was still a choice within an established repertoire: the artist limited himself to superimposing his personality on traditional themes. Watteau made his personality actually take their place.

He was no longer content to present himself within the framework provided by the memories of men or the reality of the world: for him the scene was set by the soul itself. He was perhaps the earliest to create, first for himself, then for us, a new, intimate, private universe, which, like the "invisible man" borrows from the common universe only enough clothes to make himself seen. Within this new universe, Watteau invented his own set of myths—the mythology of the self. He anticipated and fulfilled Gide's injunction: "Create out of yourself, patiently or impatiently, the most irreplaceable of beings"; and he provided that irreplaceable being with a theater in which to act out his daydreams and offer them for the delight of others. His contemporaries vaguely understood this innovation: when he was made a full member of the Academy in 1717, instead of being placed in one of the usual categories, he was put into a new and special class of his own as a "painter of *fêtes galantes*." In doing so, the Academy sanctioned the independence of Watteau's kingdom and admitted the right of an artist to add his phantasmagorical masquerade to the uniforms of other men. The individual and his unfettered imagination were given the freedom of the city.

The connection between historical determinism and personal freedom is such that even in releasing the individual from mimesis, Watteau was a man of his time. He brought about a necessary stage in the evolution of European art. To some extent, his bid for independence remained a historical inevitability occurring at its predetermined hour. But from historical inevitability he derived the freedom to be himself.

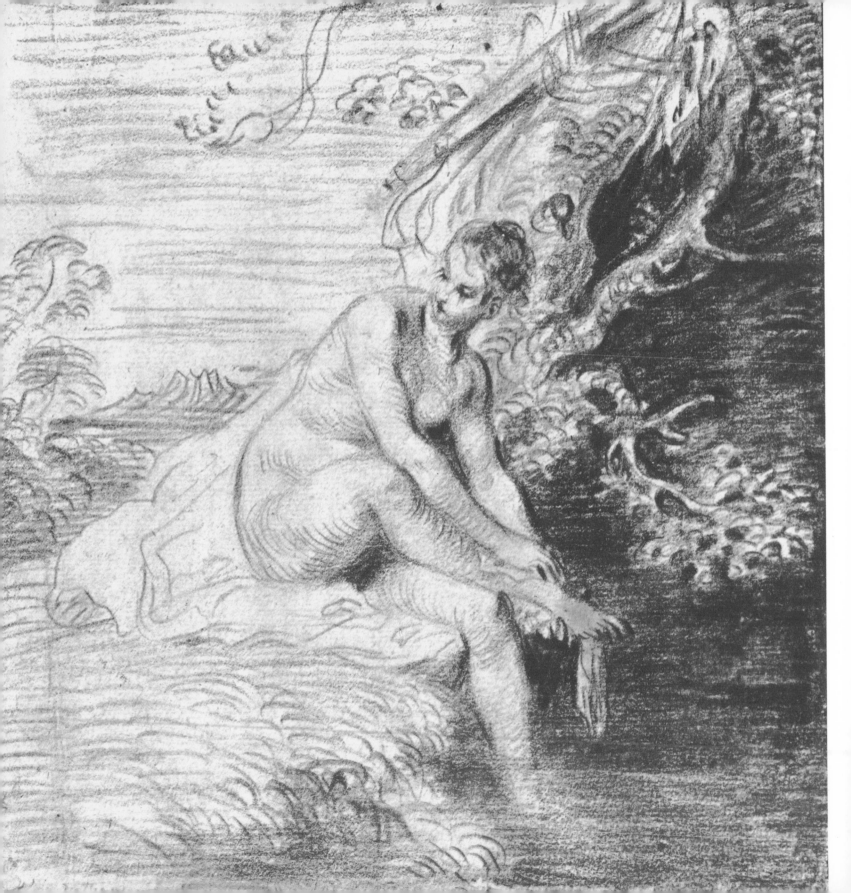

II

The Inner Self

Watteau's contribution to art seems to be without precedent. Yet he did have a precursor, one in whom he almost had a previous existence. Two centuries earlier, with Giorgione, there had begun to flow the hidden stream that in Watteau was to burst forth into the light. We now pass from the study of outer contingencies to that of inner dispositions, from the historical plane to the psychological, from relationships ordained by circumstance to the secret analogies connecting different human beings.

16. Study for "Diane au bain" Red chalk
 Albertina Museum, Vienna

Giorgionism

Watteau belongs to the family of Giorgione. Undoubtedly, he saw the *Concert champêtre* (Rustic Concert) in the King's collection, studied and analyzed it, and found in it a revelation of himself. All his dreams were prefigured there: Woman, mysterious Nature, Love, and enveloping Music combine their magic power. Longing for Italy, the young academician was obliged to seek it in its masterpieces, especially those of the Venetian school which were in Paris and the Royal collection. His eyes must have lingered over Titian's *Allegory of Alfonso of Avalos*, Correggio's *Mystic Marriage of St. Catherine*, and the landscapes of Leonardo, which told him of mountains he had never seen, veiled in the double mirage of distance and pictorial imagination. But, above all, he felt the influence of Giorgione.

Giorgione showed him the transition from reality to dream: dream which has become an extension, an emanation of reality like a fragrance. He revealed a dream that was like Watteau's own, in which tender desires were confided in the soothing, almost nostalgic mildness of a season approaching its end and a day nearing its twilight. Finally, for Giorgione as for Watteau, the subject was no longer the point of departure for poetic reverie but its fulfillment and consequence, the nucleus around which the nebula condensed. Usually, an artist chose a theme from which he then developed many levels of sensibility. However, in the *Concert champêtre*, as in the works of Watteau, sensibility was the source which gave rise to the imaginative effort that resulted in the discovery of the subject.

The consequences were profound. Before Giorgione, and even after him until Watteau, the subject remained descriptive. A picture was a narrative told in images. Each character played his part through attitude and expression rather than words. The painter appealed to understanding as much as to feeling. But Giorgione and Watteau aimed only at creating an impression that would act, like music, directly upon the heart. A picture no longer had to be understood: it had to be felt and imagined.

But Giorgione died too soon. Only a few imitators pursued his themes which are so mysterious to the mind and evocative for the heart. Titian absorbed Giorgione like a great river swallowing up a tributary, and in Titian's magnificent vitality only traces remained of Giorgione's new invocation to music and poetry. The triumphant health of strong constitutions seems to predispose their owners toward fulfillment in the life that surrounds them rather than withdrawal into the self. The strong constitution tends to be expressive and to associate itself so closely with human society that it embodies its whole age. In contrast to these extroverts are the introverts, presented to us by modern psychology, of delicate, fragile temperaments. They shun the external world that threatens to crush and disperse them. Their nervous energy that predominates over

muscular or physical strength seeks relief in inner contemplation. Those who continued the artistic revolution begun by Giorgione in Venice happened to belong to the race of Titans: Titian, Veronese, and Tintoretto in the sixteenth century and Rubens in the seventeenth century all preferred public proclamation to intimate whispering and a fanfare of trumpets to the gentle violin of solitude. They returned to the tradition of descriptive art and so were in tune with their time. For them, mythology, history, and religion all had their place with the pomp so easily understood by the masses. With them, the mysterious confession of the soul was interrupted; it would have to wait two centuries to find favorable conditions in Watteau.

However, they retained something from the movement toward intimate confession. To the explicit language of character and action, of expression and mimicry "as vigorous as deaf and dumb language" (as Molière said of Mignard), they added an implicit language. Suggestion complemented the narrative. The power of stirring the emotions, "of inducing diverse passions in the heart of the beholder" (as Poussin said) was achieved through converging impressions of color, rhythm, light, composition, and allusion. In the seventeenth century, Poussin, Claude, Vermeer, and Rembrandt, among others, all possessed these magic powers that spoke to the soul without needing to be understood by the reason. But they used them only as an accompaniment to traditional subjects. Watteau, returning to the pure essence of Giorgionism, rejected this compromise: he would make a painting into a sensitive musical instrument on which a consciously unique human being might reveal his uniqueness to others, moving their hearts to beat in unison with his own and with the sound of his playing.

It is now possible to assess the way in which history and Watteau's individual temperament worked together to bring about the revival of Giorgionism. On the one hand, the individualism which had sprung up during the Renaissance but been suppressed by the Counter Reformation and the absolute monarchy, saw its hour come again with the Regency and the reaction against Louis XIV. On the other hand, it found an ideal soil in the nervous, restless temperament of Watteau. Military disaster and increasing widespread poverty proclaimed the failure of the state and the promises it made in return for its imperious demands. Sadness and bewilderment stalked everywhere in the dark and hopeless twilight. People were weary of what was vanishing and, as yet, there was nothing to take its place. In periods of depression and resentment against authoritarian regimes that have subjected people, then disappointed them, men always feel a need to turn within themselves and to seek compensation for disillusionment in dream. In Watteau this need made the demands of his own nature all the more imperative.

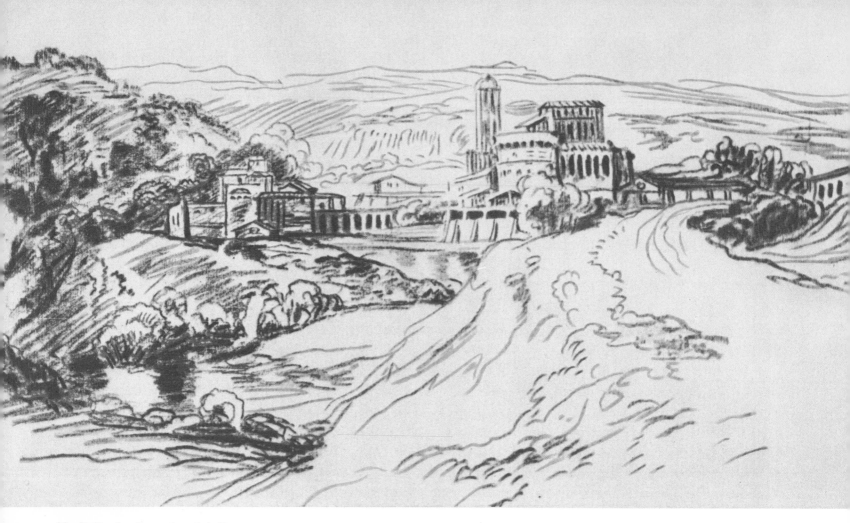

17. Italian landscape in red chalk
 Private collection

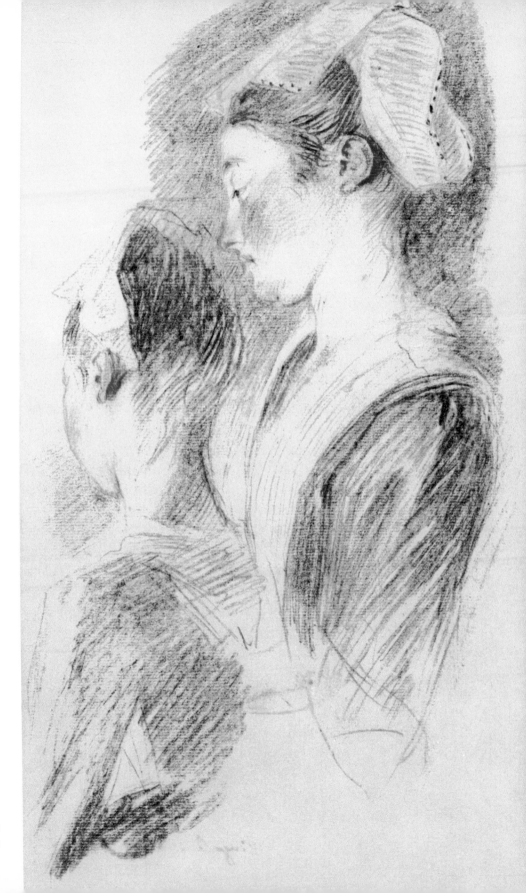

18. Study in black and red chalks
British Museum, London

Watteau's Constitution

Watteau was one of those people whose delicate health makes them somehow unsuited to reality and vanquishes them in advance. He is made known to us by his contemporaries, his own drawings of himself, and the moving etching by Jean de Jullienne showing Watteau and himself side-by-side. Here, we see a tall, supple form, somewhat stooped, that turns aside as if in secret fear of having to confront reality; a thin, gaunt, suffering face with enormous eyes; hands that, like those of his own characters, seem at once sensitive, strong, and caressing. There is something restless yet meditative about him: an appeal and, at the same time, a withdrawal, an abandon and fear.

It is easy to see that his body lacks muscle and flesh: all the vital energy is contained in his nerves. Deprived of the stabilizing counterweight of matter, they acquire an acuteness that transforms everything into vibrations, into an intensity too rapidly exhausted, into extreme and consuming joys and sorrows.

If it is true that an artist, without wishing or knowing, leaves his mark on the world he represents and tries to make it resemble him, Watteau would have seen out of the whole spectacle only the things that corresponded to his own nature. He would play down matter and exalt all that escaped and broke free from it. His universe would not consist of the heavy, corporeal men and women of Michelangelo, Titian, or Rubens. Slim and nervous, they have that upward elongation that corresponds to a desire to escape from reality and that is evident even in Watteau's early drawings. It is seen in the art of mystics like El Greco, whose creations yearn upward like flames; in subtle and refined painters like Van Dyck; in mannerists like Parmigianino and Primaticcio, who distorted established, overfamiliar forms to give them new piquancy. Even if he did not know El Greco, Watteau certainly must have appreciated Van Dyck, with his supple dreamy youths clad in rich satins that shimmer in the shadow of autumn and evening. Watteau retained the anachronistic costumes from the time of Charles I. He knew Primaticcio, and Parmigianino through Audran's teaching, La Fosse's admiration, and Crozat's collection.

Attenuation of form is a mode of expression and instinctive symbol of all those who long to escape from their material condition, whether through the faith that raised up cathedrals toward heaven or through elegance, that more commonplace aspiration toward transcendence and liberation. Like Van Dyck, Watteau was at once drawn to this device by the tendency toward refinement of a nature more nervous than robust, and by the desire to add new sharpness to the faded flavor of the familiar. Watteau was born out of satiety with Poussin and his rich and powerful equilibrium made ponderous by Le Brun, just as Van Dyck was born out of satiety with Rubens.

Aspiration toward the immaterial was reflected first of all in Watteau's style. He shunned all shapes expressing fullness, the regular symmetrical forms against which the early eighteenth century was beginning to react. The oval beloved of Audran often underlies his compositions. Like El Greco, Watteau sometimes built his compositions up from a point rather than from the stable, flat base of a classical pyramid. In such cases he often made the principal lines converge in diagonals that end in the point of a slipper. His drawing obeyed the same tendencies. He began by using a bare, straight line that created slim and precious figures, but he grew to prefer a line that was sinuous and wavy. It came naturally to him. In one of the rare drawings done from imagination, without a model, his hand spontaneously set down a network of lines like mounting flames and wreathing smoke. It is not impossible that Hogarth was influenced by Watteau when he made this S—like curve, the "line of beauty," the basis of his æsthetic. This line, so dear to baroque painters, especially Rubens, is the foundation of almost all of Watteau's compositions. Only when he was unsure of himself did he give in to the strict horizontals and verticals that the classicists favored. Even in the early military scenes, he made use of the rise and fall of the land, using curves to outline the planes and arranging the figures in a farandole.

At the same time that Watteau represented form in its subtlest and most airy manifestations, his brush eliminated from matter anything that does not stimulate sensation. He had inherited from the Flemish painters a skill in glazing that made possible the most dazzling *trompe-l'œil* effects and, at first glance, his painting seems to share Flemish realism. However, like the Venetians and their disciple, Van Dyck, he retained only the most intangible and fugitive effects of realism. He presented the skin of things but not their structure: the foliage is light as mist, the materials sparkle, the flesh is soft and silky, and even the stone of the statues seems alive. A subtle sifting reduces reality to its most delicate and airy aspects but, at the same time, gives it such intensity that it seems more present than it did in life. The real world, that in which men live, could not with all its brutality, provide Watteau with the select impressions he needed: he could not dwell there. Men of flesh and blood, vulgar and greedy, false and heavy, lacked the tender delicacy of which he dreamed and by which he was inspired. All Watteau's friends commented on his exacting nature. Jullienne said: "He had a lively and penetrating mind and elevated feelings" (*Abrégé de la Vie d'Antoine Watteau*, 1735). Comte de Caylus, "He had wit, and though he had received no education he was a shrewd and even subtle judge of music and all the other products of the intellect" (*Vie d'Antoine Watteau* ..., first read 1748). Imagine, then, what a judge he must have been of men. He saw through them but tolerated them through weakness:

Caylus said that he was "continually the dupe of all around him," for, "though his mind discerned all, his weakness let him be taken advantage of". Then he would withdraw and be accused of coldness. Jullienne described him as "by nature cold and indifferent towards those he did not know ... he had no other fault but that of indifference." This was because he suffered too much if he became involved. Gersaint speaks of "the painful sorrows with which his life was interspersed" (*Catalogue ... Quentin de Lorangère*, 1744).

A true son of his century, Watteau dreamed of a society in which human contacts were reduced to the pleasure one gave and received. He loved society, but with too much exactingness not to flee from it when he encountered reality. Then he would seek refuge in solitude and the self, where he cultivated his own images in order to escape those imposed upon him. Romanticism was not born yet, and his contemporaries were confused by this attitude. They recognized, as Caylus did, "the gentle expression that was natural to him"; but they observed that not only was he "cautious and reserved with strangers," but also "impatient and shy" (Gersaint), and even "gloomy, melancholic . . . irritable" (Caylus). They were astonished when he withdrew into the shelter of his thoughts (Gersaint notes that he "was very fond of reading, the only amusement he sought in his leisure moments"), where he discovered his own true nature. But confronted by others, disappointed and hurt by them, he was sometimes "critical, malicious and mordant" (Gersaint). Caylus says that he was "born caustic," and "revenged himself on people who annoyed him by depicting the character and mannerisms of those who irked him most." However, this did not stop him from being "taken in by them in little things."

So he suffered and made others suffer because of his "social deficiencies," "always discontented with himself and with others, and slow to forgive". He needed solitude in which, according to Caylus, "far from all annoyance, the Watteau who elsewhere could be so gloomy and irritable, shy and caustic, became the Watteau of his paintings, altogether charming and affectionate and even somewhat pastoral." Why not dream reality rather than experience it? Why not withdraw from real life to the pleasure of composing an imaginary life where one is free to become oneself, to conform and make others conform to one's desires? Why not go where one is free to be?

19. Study for "Le Plaisir pastoral" and "Les Bergers"
Lead pencil and red chalk

Musée Cognacq-Jay, Paris

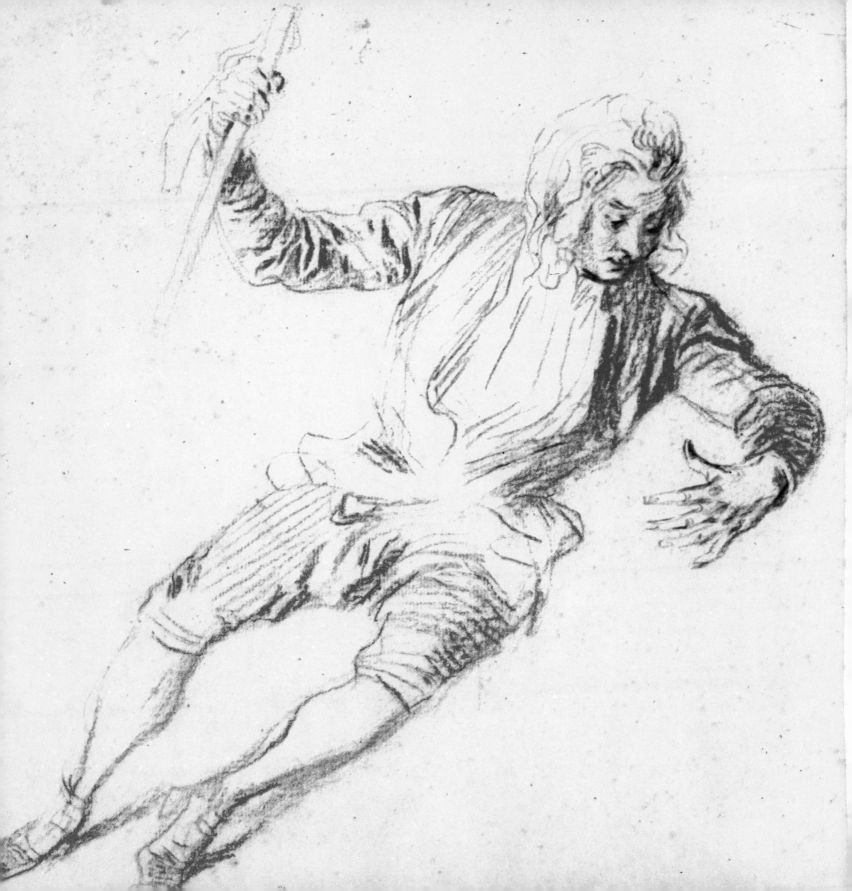

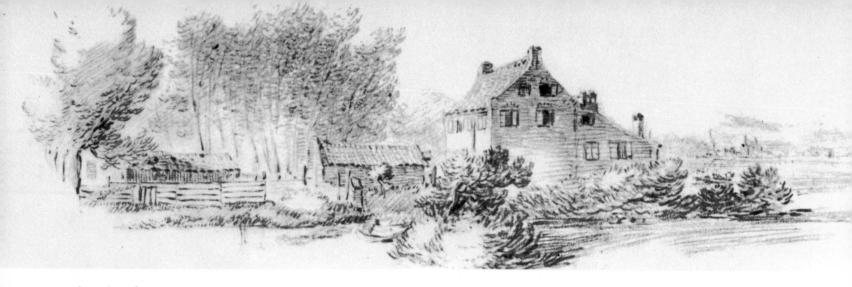

Adolescence

Touchiness and intensity, fastidiousness, idealism doomed to shy withdrawal, melancholy, escape into the imagination, a mixture of ardor and timidity, a desire for and fear of life: these are often characteristic of adolescence. Nerves too new and sensitive are not yet protected by the covering of maturity. Experience has not yet strengthened—or roughened—the skin. As Watteau was, so, more or less, were those other eternal adolescents, Botticelli, Giorgione, and Van Dyck. It seems as if every man were made for some special age in life, which he waits for, recognizes, and adopts as his. Like the others, Watteau reshaped the universe according to his own requirements. His was a universe inhabited by tall, slender young men and women, all possessed of the emotional delicacy that arises out of the imponderable and can support nothing else; the stronger sensations necessary in more developed and therefore more blunted men would only stifle them. And the god who reigns there is the god of love.

Watteau's universe exists only through the impulses and agitations of the heart: it does not belong to the stolid stance of maturity. It is dazzling, but half unreal. Watteau embraces it in a grasp at once close and confused, like Ixion embracing Juno in the form of a cloud. He asks trees and foliage not for weight and form but for depth and shadow. The earth he asks for distances, the sky for blue mornings and glowing dusks. Against this vague and dreamy background he had to have some creatures more prominent to answer the requirements of his heart. He discovered these among animals. How attentive Watteau was to animals, especially the most gentle and familiar ones, has probably not been noticed sufficiently. Cats are rare in his pictures and usually just playthings for children. Sheep and cows enliven the landscapes. Horses are frequent, either rawboned old nags as in *L'Abreuvoir* (The Drinking Place) or gleaming coursers as in *Le Retour de Chasse* (Return from the Hunt). The ass, nearest of all to pitying hearts, gazes almost humanly from the center of *Gilles*. But dogs are his favorites. Almost every picture has one, either sleeping obliviously, asking to

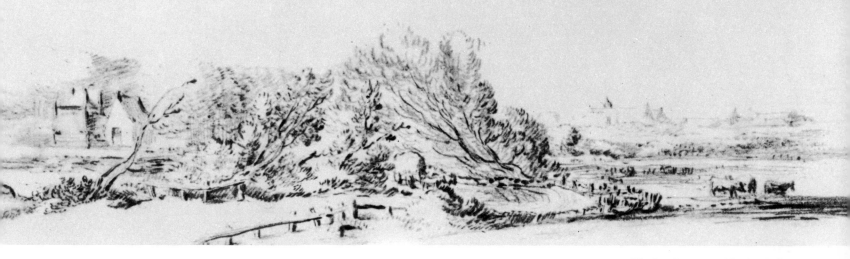

20. Landscapes in black chalk
Ashmolean Museum, Oxford

be stroked, prancing about in front of sweethearts, or prosaically scratching his fleas. They are separate, recognizable individuals: sometimes there is the big black and white dog, casual and sleepy, and sometimes the petulant, noisy little spaniel darting everywhere.

Dearest of all to his ardent adolescent heart was Woman. Her mere apparition, her curved waist draped in shimmering silks, her refined, elegant movements—only these could fully answer his need for fineness and delicacy. Above all, it was she who would greet and understand this soul, solitary only because of too exacting a need for love. Due to her and her welcoming glance, smile and kiss, the rough and disillusioning external world would open up. Love abolished the harsh paraphernalia of words and explanations, misunderstandings, and enmities with which men confronted one another and which crushed Watteau. Another being prepared itself for yours, and tried to become like it!

Jules Laforgue, who was the poet of Pierrot as Watteau was of Gilles, wrote :

> *Jupes de quinze ans, aurores de femmes,*
> *Qui veut, enfin, des palais de mon âme?*
> *Oh! qu'une, d'Elle-même, un beau soir, sût venir*
> *Ne voyant plus que boire à mes lèvres, ou mourir!...*

(Petticoats of fifteen, dawn of Woman, Who, then, wants the palaces of my soul? Oh! that one, of her own accord, some fine evening, might come With no desire but to drink at my lips, or die!)

"Die"—on Laforgue's lips the word was close to love, just as it was the key to both their brief lives. Throughout the poetry of adolescence, in Watteau and in Laforgue, is heard the final murmur of Hugo's *Legende* :

> *Puisque, tôt ou tard, nous mourrons* ... (Because, sooner or later, we must die ...)

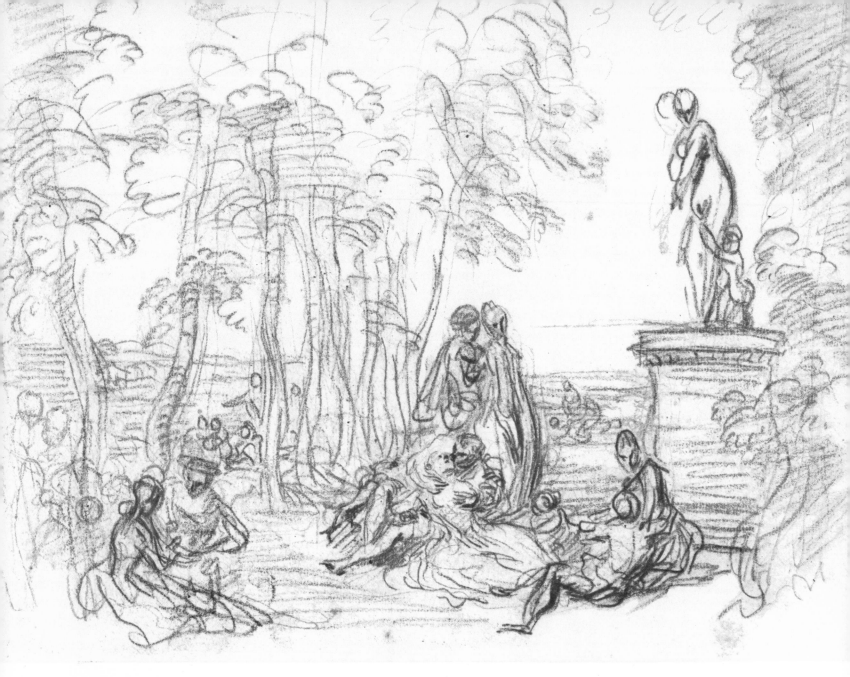

21. Sketch for "Plaisirs d'Amour"
Red chalk and pencil

Private collection

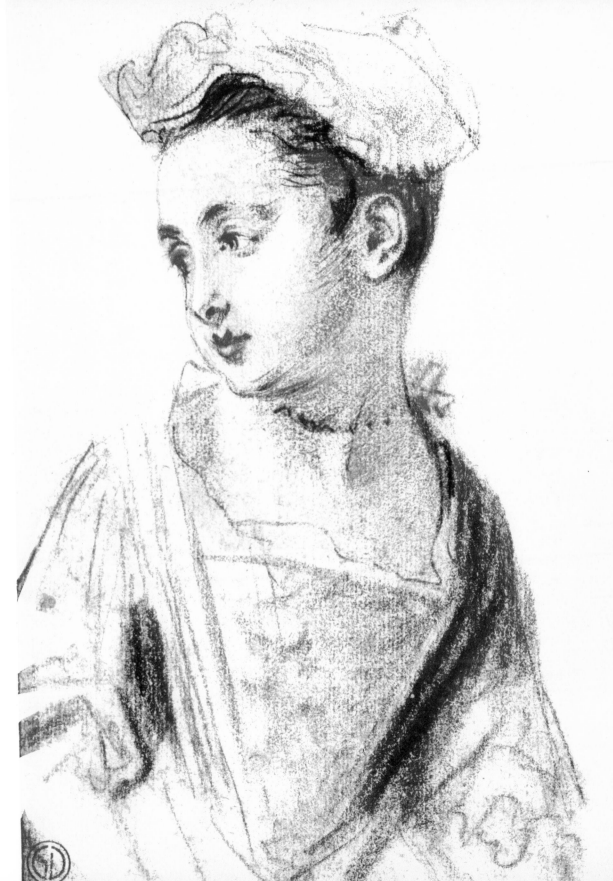

22. Study in black,
red and white chalks

Private collection

The Ill Adolescent

It is not enough to say that Watteau was an adolescent: he was unhealthy as well. Both Jullienne and Gersaint say that he had a weak constitution, undermined by what was then called consumption. What Dezallier d'Argenville calls "a temperament as delicate as his" (*Abrégé de la vie des plus fameux peintres. . .,* 1745) could not hold out long, although he resisted ten years longer than Laforgue. This ailment intensifies the imbalance between nervous exaltation and physical frailty already created by adolescence. It refines this delicacy as it gives to the ardent soul the flame that burns visibly in the cheek. Desire grows sharper and more consuming as hope of fulfilment fades. Thirst becomes more acute, and the water slips between the thin fingers.

Dreaming becomes only a musing on what might have been. With it comes haunting melancholy which becomes regret. To be sure, sadness is not definite in Watteau; it is not to be seen on those carefree faces. And yet it lies everywhere. It is sadness that transforms a brilliant morning into a sunset, green foliage into brown leaves, the reds and blues of a Fragonard into dull garnets and purples, and adds to youthful desire a note of wistfulness that normally belongs to age.

Watteau is defined by this mixture of youth and premature weariness. Thus he is related to a family in whom poetry delights: the family of Giorgione and Van Dyck, in which youth assumes strange colors, flamboyant yet dying. In the other arts he belongs with Mozart and Chopin, Keats, Shelley, Musset, and Laforgue; to a procession of gentle phantoms who gave themselves completely in the flower of a genius that would never ripen to fruition.

The reality they reflect is strangely altered: it appears to be intact, but in fact there is an invisible and haunting gap. What is missing, in a word, is the present. Man can experience reality in three tenses: in the future through desire, in the present through possession, and in the past through regret. Here, it seems as if the most important, the present, has disappeared. The universe of these artists, Watteau's universe, lives intensely but in expectation. Things resemble not what is true but what is wished to be true. Presence, objective presence that puts desire to the test of reality, is avoided. All is desirable, nothing is real.

And so nostalgia makes its appearance. Desire looks to the future; it accelerates time with almost painful acuteness; it hastens its death in either satisfaction or disappointment. Irresistibly, it invokes the melancholy of the irreparable, the passing hours. That is why young poets, more than others, have sung of fleeting time. So what can be expected of one who is exhausted and ill, and in whom desire burns more fiercely through dread of unfulfillment? His ardor is intensified by over-stimulated nerves; the fever of lost opportunities and the

sense of being exiled from life are increased. Laforgue once more gives utterance to this lament:

Soigne-toi, Soigne-toi! pauvre cœur aux abois

. . .

Oh! ce ne fut pas et ce ne peut être
Oh! que nous mourrons!

(Take care of yourself, take care poor heart at bay

. . .

Oh, it was not, and cannot be
Oh, let us die)

Watteau gave shape to this world that has no present: departures, embarkations for Cythera, delightful hints of love, waiting for the other person, expected but still unknown and offering only grace. Desire dominates here. But there is also nostalgia: walks where conversation dies out and the pace slackens as it will on the eve of farewell. Perhaps this will be the evening to part. Night falls and there is silence. The day vanishes, happiness passes, the parting comes, and all could have been a dream.

Sometimes Watteau's illness showed its paler face and pulled aside the veil of poetry. Like Bellange, he revealed a morbid acuteness. Sharpness reaches its peak in the thin legs, slim and strangely angular feet, and hands. About 1715, the hands acquired an unhealthy appearance. Watteau thought about nothing else and covered page after page with sketches of them. In Berlin there is an impatiently scribbled drawing of a bass viol player in which only the hands really exist: bony, gnarled, swollen with veins and tendons, they live, palpitating in the air. For an instant the breath of fever has clouded, has just blurred, the clear mirror.

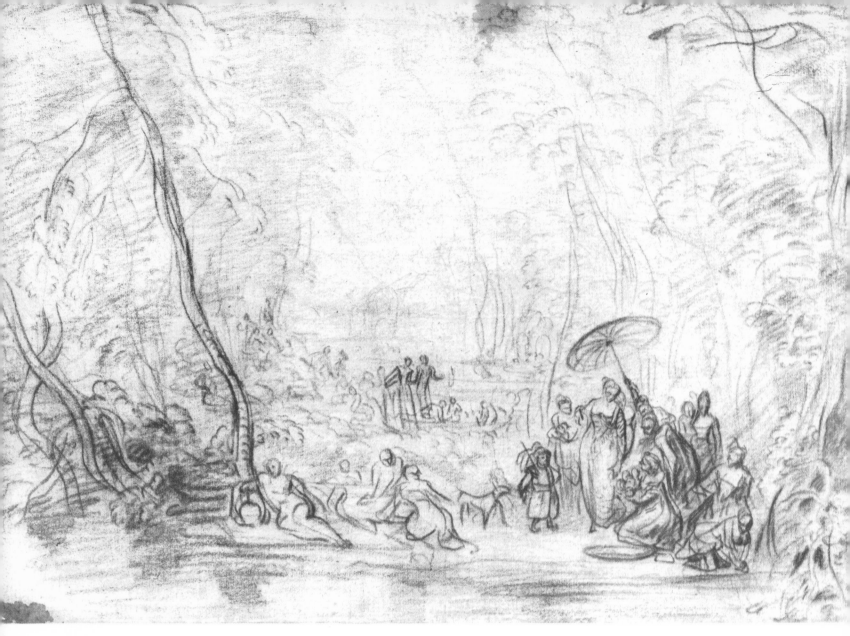

23. Moses found in the bulrushes
Red chalk

Ecole des Beaux-Arts, Paris

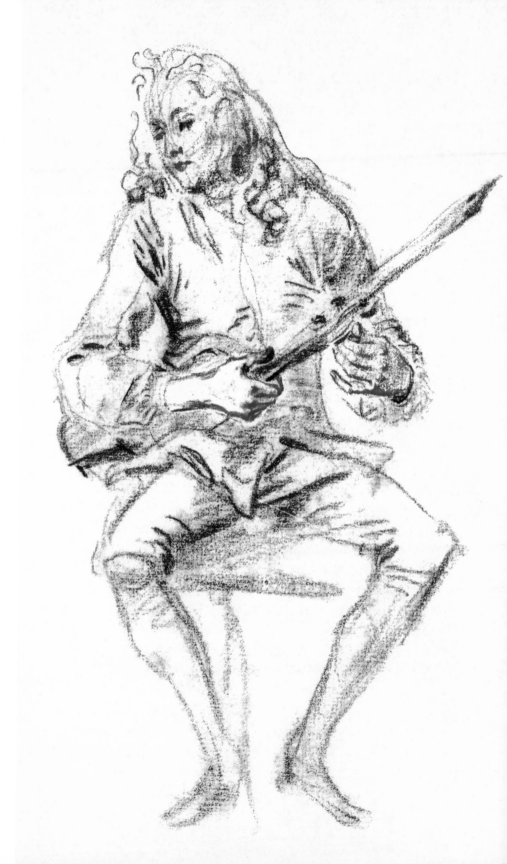

24. Study of a violonist
Black and red chalks

Rennes Museum

Space and Time

Such are the complex and fascinating factors that influenced Watteau's art. Its unique and irreplaceable tone was born from their encounter. They supplied the elements of his universe and laid down its particular laws when it assumed form and entered into time and space.

The story of painting's long and gradual attempt to master time and space has not been adequately written. At first, Western painting ignored time, confining itself to immobility, and reduced space to its simplest form, representing merely fixed attitudes on a stage defined merely by the frame. Then, slowly, depth was added by means of *trompe-l'œil* and perspective. Actually, in Poussin's time, Western painting was still at the same point: it remained a frozen scene presented frontally, although attitudes were more and more expressive of a variety of movements. Yet, shortly before, Tintoretto had multiplied space and suggested time by hurling his figures across the canvas like meteors, whose trajectory the beholder's eye is forced to continue. Painting thus acquired unlimited extension and mobility.

At the same time the actual paint, hitherto smooth and flat, had become more animated. By beginning to leave its trace, the brush indicated the gesture and speed of execution. Rubens, Hals and Rembrandt, following the Venetians, developed this new possibility to the point of expressing latent rhythm. It might even be said that they endowed painting, immobile in itself, with speed.

Here again Watteau contributed something new. Hitherto the subject of a painting and the way in which it was treated had shared the same time scale. Rubens' characters and the brush that depicted them were caught up in the same powerful vortex. But Watteau introduced a surprising and paradoxical effect: the scenes played on his stage have the indolent slowness of rising smoke or an unfolding dream. He conjured a universe as peaceful as Vermeer's: life emanates from it calmly. At the same time, the scintillating liveliness of the brush or pencil stroke imparts a movement more vigorous and electric than that of Rubens himself. For the first time, the two elements of speed that painting had just acquired broke apart to form two different registers, that of feeling and that of execution. Dreamy and nervous, Watteau projected his dreams into his imagination and his nervousness into his brush. It was like music played with two hands: as in Chopin or Liszt, the high sprightliness of one hand together with the sober depths of the other create a whole new range of encounters and contrast, and produce a completely new tone.

Here, on the one hand, is a world that ignores the present and therefore ignores action. The vagueness of the situation, the incompleteness of the gestures, the gently swaying attitudes, the figures from an imaginary ballet that have chosen to cease moving just at their most exquisite moment: all these make up a quintessential

theater in which everything alights, quivers, glides, and dissolves in the slowest of cadences. For this painted aristocracy only pleasure has meaning. But when the eye comes close enough to lose sight of the scene itself and discerns only the imprint of the artist, then everything rushes and bounds, streaks, spurts, and flashes in a shower of strokes that claw, and touches that mingle.

As well as extending the possibilities of pictorial time, Watteau also enriched the traditional concept of space. Until then painters had limited themselves to showing space from in front: everything represented was oriented toward this sort of stage opening, defined by the frame through which the spectator was supposed to be looking. Watteau set out to enlarge pictorial space. His drawings created space around the figure he was studying. He approached the subject from all directions and from every possible angle. The speed with which he set down his drawings makes them almost like snapshots. On one sheet of paper, he would draw the same head from all sides: for example, the early drawing of a bagpiper has both frontal and profile views. He kept the same diversity of views in his paintings. As he developed toward maturity, he placed his figures according to the most varied orientations. They pivot, pirouette, bow, perform every possible twist, bend, and dip, so as to suggest an infinite number of lines crisscrossing the space between them. With almost no display of it, Watteau imparted a greater sense of movement than even Tintoretto.

Watteau went even farther. He often ordered and organized these varied spatial suggestions by the graduated development, through one figure after another, of a sustained pivotal movement. Thus, he established simultaneously a space and an idea of the time required to traverse it. The process is already hinted at as early as the Gillot period, in the *Départ des Comédiens Italiens* (Departure of the Italian Players). Here figures advance, then turn, and finally straggle away in the distance. Their departure is extended by the perspective of the street along which they are about to disappear. This preoccupation is even more apparent in *L'Hiver* (Winter) from the *Seasons* done for Jullienne. Here, a complete conversion takes place in the picture from one side to the other, from front to back, and passes through the center foreground: the effect is similar to that of a searchlight sweeping through space. The *Départ de recrues* from the period of military pictures shows how Watteau broke down the movement into successive attitudes, as Marey was later to do with his photographic "gun." The soldiers—obviously based on only one model—come on from the right, pass, turn, and go off in the distance after a glum-looking officer, whose back we see as he gallops off on the left toward the horizon. This is certainly not Watteau's only kind of composition, but it is perhaps his favorite. By means of it, he reintroduced with greater verisimilitude the naive attempt of the primitives to represent by successive episodes in space an action which really took place continuously in time. This scenic progression, sensitively

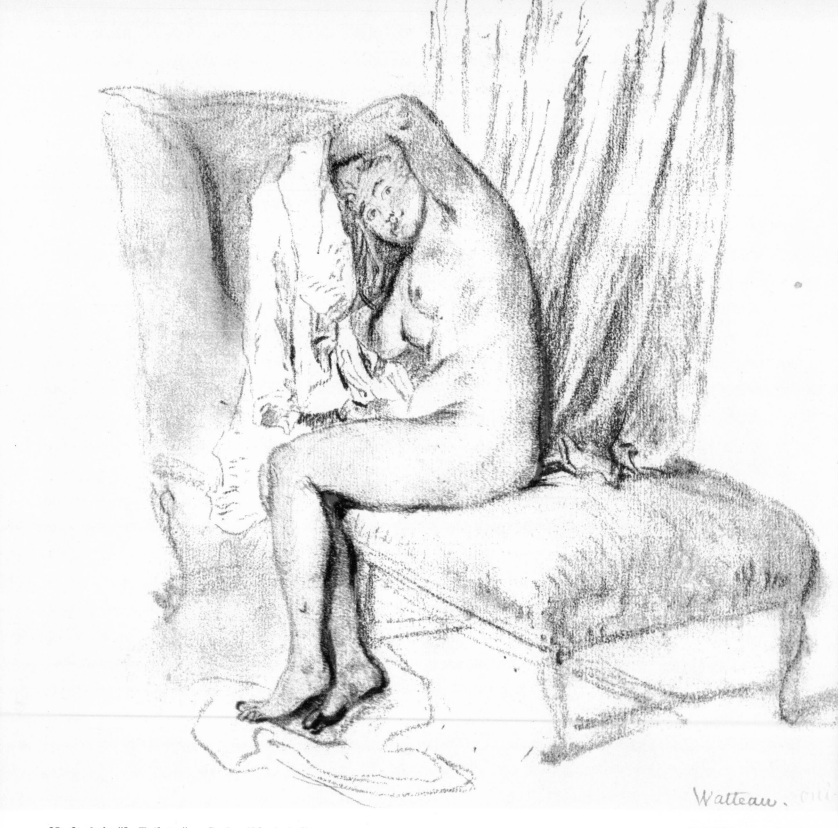

25. Study for "La Toilette" Red and black chalks

British Museum, London

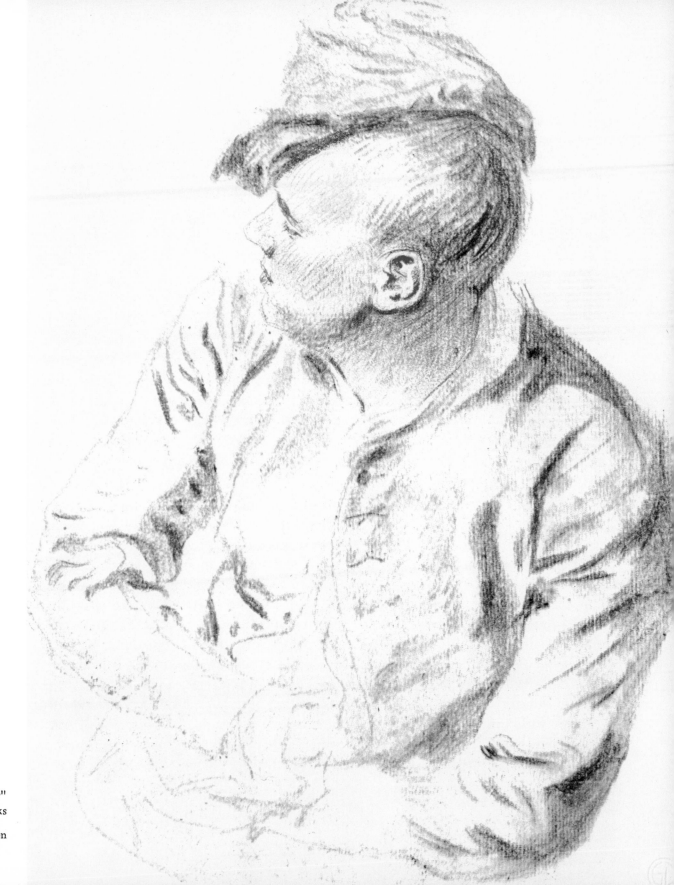

26. Study for "Le Conteur"
Red and black chalks

Private collection

analyzed by Rodin, reaches perfection in *L'Embarquement pour l'Ile de Cythère* (The Embarkation for Cythera) where it develops at once through time and space and the dimension of feeling. It moves from attentive immobility to yielding hesitation, and then abandons, with the departure of the enchanted boat, for the distant island. The same composition is found again in the *Les Plaisirs du Bal* where the figures are ranged along an imaginary vector across space: shown frontally on the right, they progress to the left, where, now seen from the rear, they vanish toward a patch of sky; in the *Fête d'amour* (Love-Feast), where the progression is from left to right; and finally in the *Rendez-vous de chasse* (The Hunters' Rendez-vous), where the couples dismount on the right, chat in the middle, then rise and go off into the distance on the left. Composition in the form of a procession, composition in the form of a dance—it is like the shifting changes of a daydream.

The most ardent and dynamic source of this mode might be found in Rubens: it was just one of a hundred suggestions let fall, as from a cornucopia, by this profusively inventive genius. Watteau took hold of it and adapted it to his own very different sensibility. It is noteworthy that, unlike most painters, he involuntarily preferred to unfold his composition from right to left, just as he let it drift, like a boat in an irresistible current, toward the background, toward the horizon, as if fleeing the stage where it was supposed to be presented. These two directions, which the spectator unconsciously experiences, contribute to the paintings' pervasive poetry of nostalgic decline.

For us, space is charged with so many meanings from our experience that it cannot help but cause real subjective reactions that vary with the artist's handling of it. These inner states are instilled in us in a way that is beyond our control, as if by musical or rhythmical laws governing our feelings. A composition organized from right to left affects us differently than one from left to right. Our hand moves most naturally in the latter direction, and the diagonal ascending towards the right is therefore a particularly frequent type of composition. Rubens, for example, used it often. It represents an almost spontaneous gesture. Its opposite involves much more concentration and a more difficult muscular effort, and the corresponding composition is therefore, fairly rare. Moreover, Western writing, going from left to right, has accustomed us to expect the meaning of a sentence to unfold progressively in the same direction. Any converse movement is subconsciously associated with the idea of going against the stream, of regression toward the past, of opposition to the natural course of things. For many centuries, the right has been associated with the idea of good and the left (*sinistra* in Latin) with that of evil. These obscure factors determine the instinctive space symbolism that we all carry within ourselves to a greater or lesser degree. Just as Rubens' "right-handed" movement speaks to us of joy and of strength moving easily into the future, so Watteau's frequent ebbing back in the opposite

27. Study for "Les Agréments de l'Eté"
Black, red and white chalks Louvre, Paris

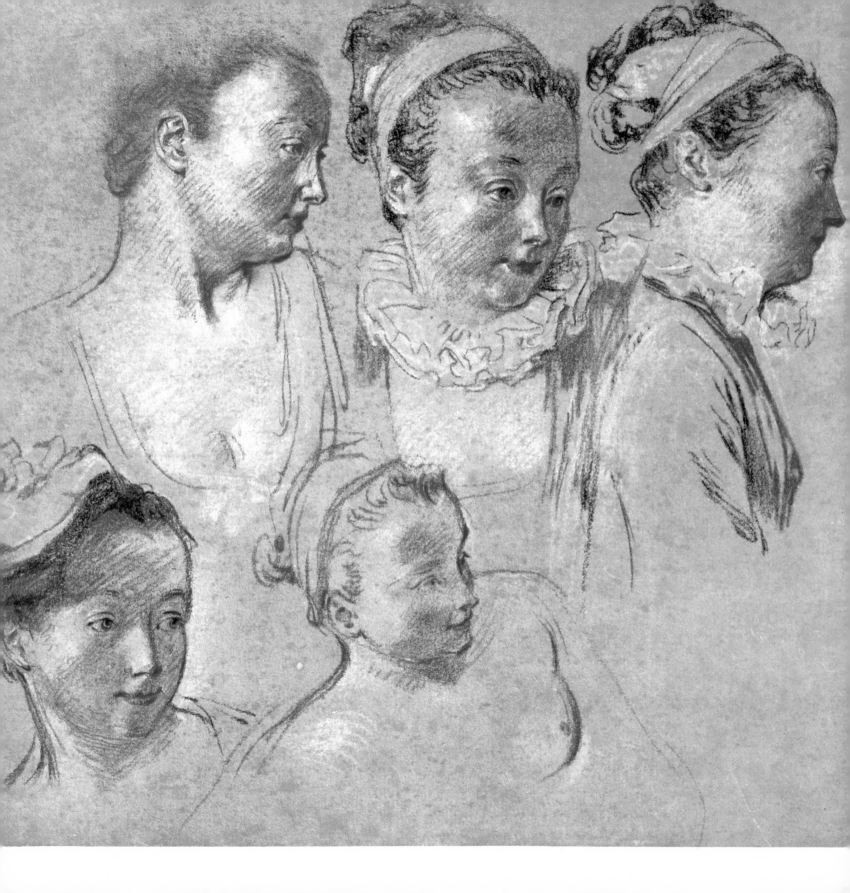

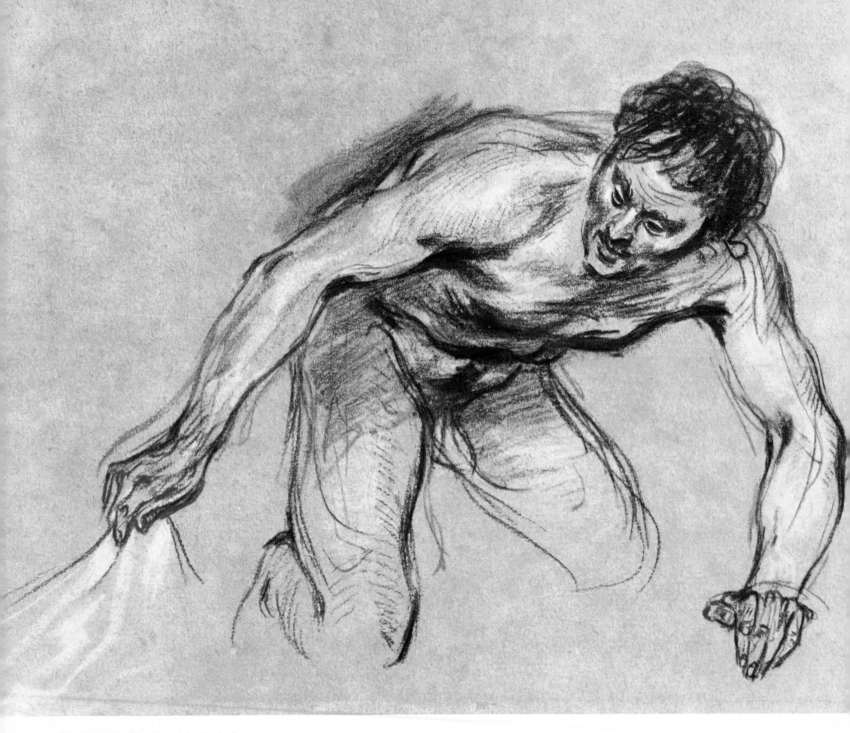

28. Study for "Jupiter et Antioche"
 Black and red chalks, white wash
 Louvre, Paris

29. Flora, study for "Le Printemps"
 Black, red and white chalks
 Louvre, Paris

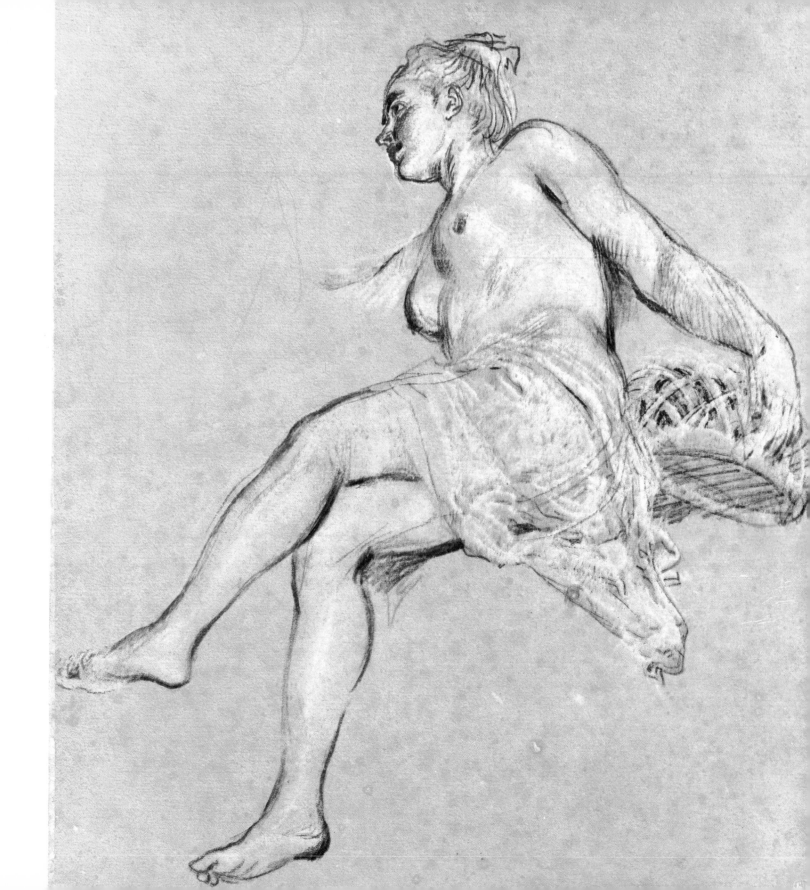

30. Study for "Les Plaisirs du Bal" in black, red and white chalks

Louvre, Paris

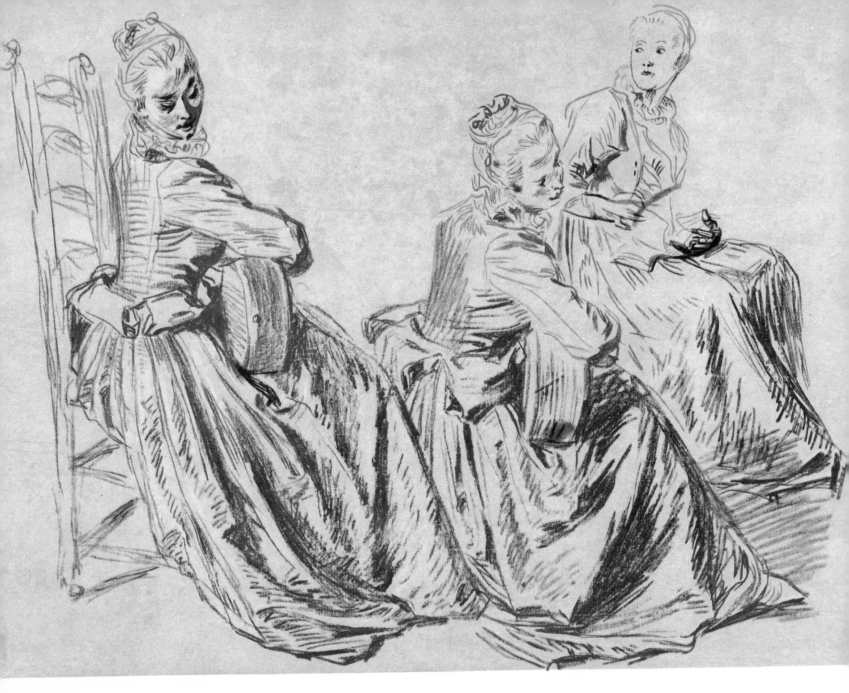

31. Study for "Les Charmes de la Vie"
Black chalk, lead pencil, and touches of red chalk

Louvre, Paris

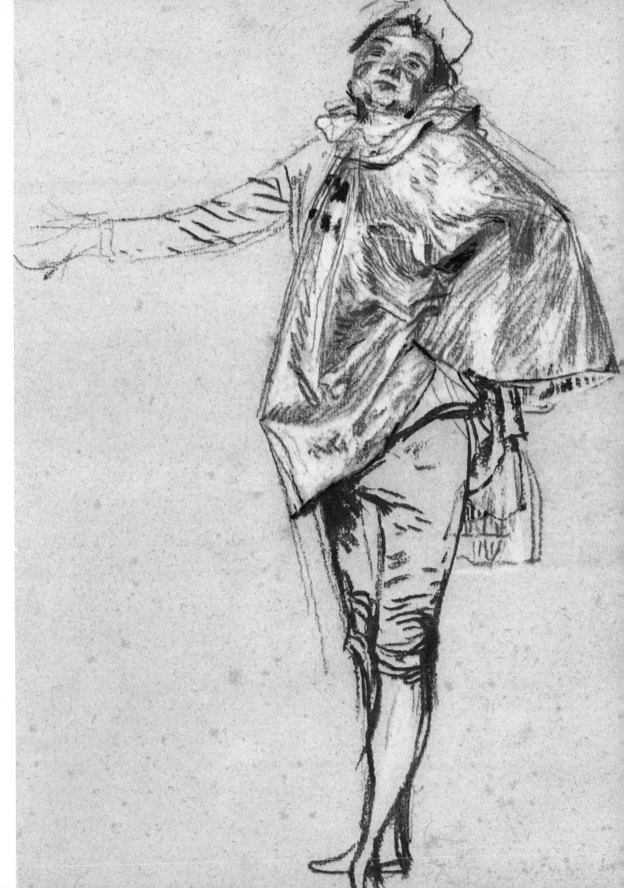

32. Study for "L'Indifférent"
Black, red and white chalks

Boymans Museum, Rotterdam

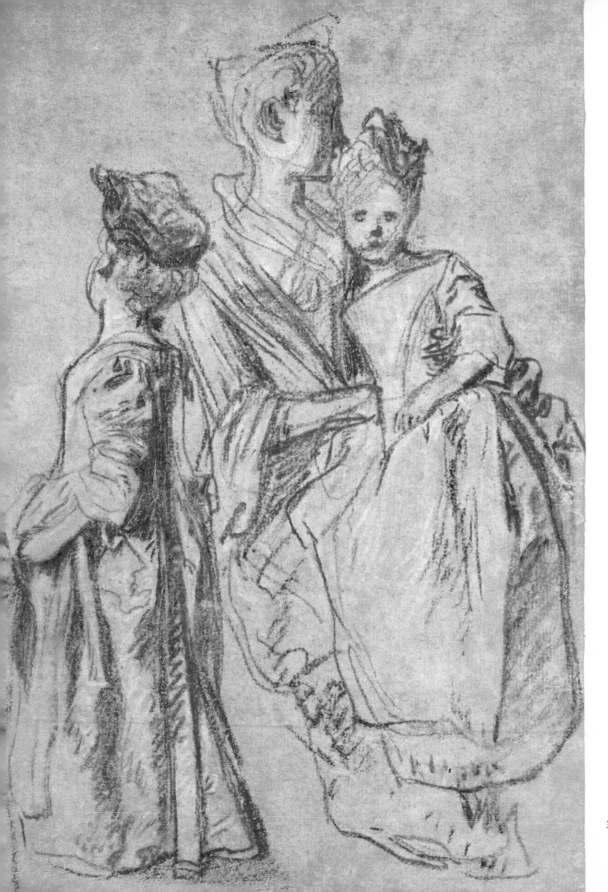

33. Study in black, red and white chalks
British Museum, London

direction gives us a vague sense of a deviation of life, a rejection of reality, and a flight toward a world of nostalgic shadows.

Even clearer is the language with which the distance speaks to us. It is linked to departure and the unknown. It awakens in us dreams long repressed of the desire to journey, and the sadness of all that leaves, disappears, and perhaps will never return. In Lorraine this poetry resounded in the solidity of rectilinear architecture and perspective. Watteau kept only the imperceptible transition toward disappearance.

While a painting had until then offered the beholder a scene deliberately spread out before him, Watteau made it elusive, like his women's faces always ready to hide behind a fan. He shows us an exquisite vision, but one that vanishes, appearing only to disappear: the breast of a mermaid glimpsed just as she dives back into the depths, the city of Ys seen before it sinks beneath the waves.

Not one person who approaches us really addresses us: they all pass by as if we were not there. The only exception is *Gilles*, Watteau's perfect double. He alone, Watteau's *semblable, son frère*, can look straight in front, as if he were the artist's reflection in the mirror. The other characters, gliding and escaping, return to their unkown origins. We stand on the edge of the scene as on the bank of a river where happy barks float slowly by and music fills the air. They take no notice of us; for an instant they let us glimpse their pleasure, and then they disappear.

We do not belong to this shimmering Elsewhere that flows by at the speed of time. One minute they are there, those brilliant marionettes, and the next they have turned on their high heels, looked back, and are gone. No other painter has ever viewed so many of his characters from behind. The nape of a neck with wisps of curls escaping; bared shoulders in a low-cut gown; a cap pushed back so as to conceal a lover's profile; a carelessly draped cloak; all these remind us that the universe of Watteau is called Elsewhere. An elsewhere that eludes us, that is going toward its own elsewhere—the distant. Through a gap in the trees it harkens to a seductive call, a call that seems to inhale the picture and draw it toward the gleaming, mysterious depths where all dissolves.

Sometimes this Elsewhere takes a visible form. It is the Island, the distant island in the background, decked in the colors of the setting sun. It is a land of fabulous treasures, such as were revived in men's imaginations by the Eastern embassies, and the new trade companies that spoke of the Indies, the unforgettable Golcondas.

In Watteau's last paintings the space of this unreal theater, which earlier lay open before us, is closed. A fence, bench, balustrade, or flight of steps in the foreground marks a frontier that we may not cross: Watteau's fugitive world lies beyond. As early as in *L'Embarquement pour l'Ile de Cythère* the procession goes up a little

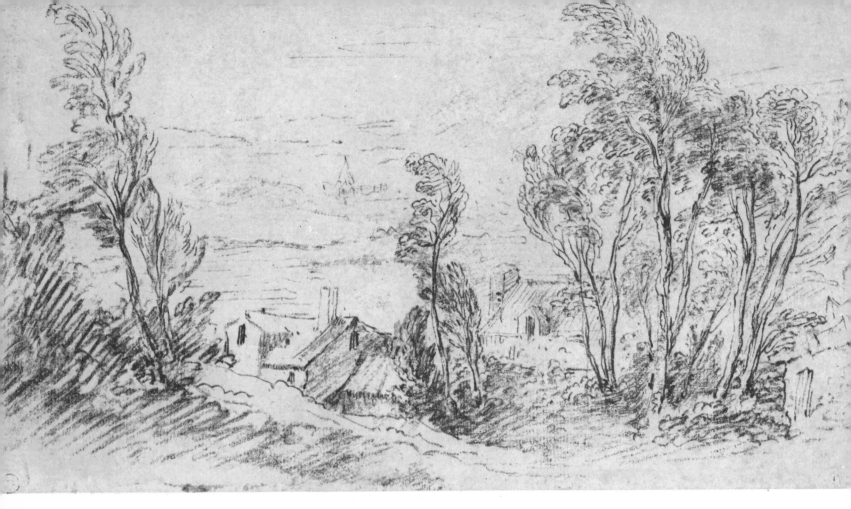

34. Valley of the Bièvre in red chalk
Musée Fabre, Montpellier

hill and descends half-hidden behind it, like the minor figures surrounding *Gilles*, the only person left on the near side with us, the living. Already also in *Les Charmes de la vie* the picture is only the threshold of an opening door. And in the *Réunion champêtre* (Rustic Party), and the *Assemblée dans un parc* (Gathering in a Park), the figures are about to pass beyond the horizontals of stone that run across the foreground. In the *Divertissements champêtres* (Rustic Amusements), a screen of trees marks this threshold; in *L'Enseigne de Gersaint* (The Sign of Gersaint), a road and a sidewalk.

By all these intangible factors, which Watteau felt and which are felt by us only dimly though we are completely under their influence, Watteau gave their own local color to the scenes of his imagination, the half-caught glimpses of his dreams.

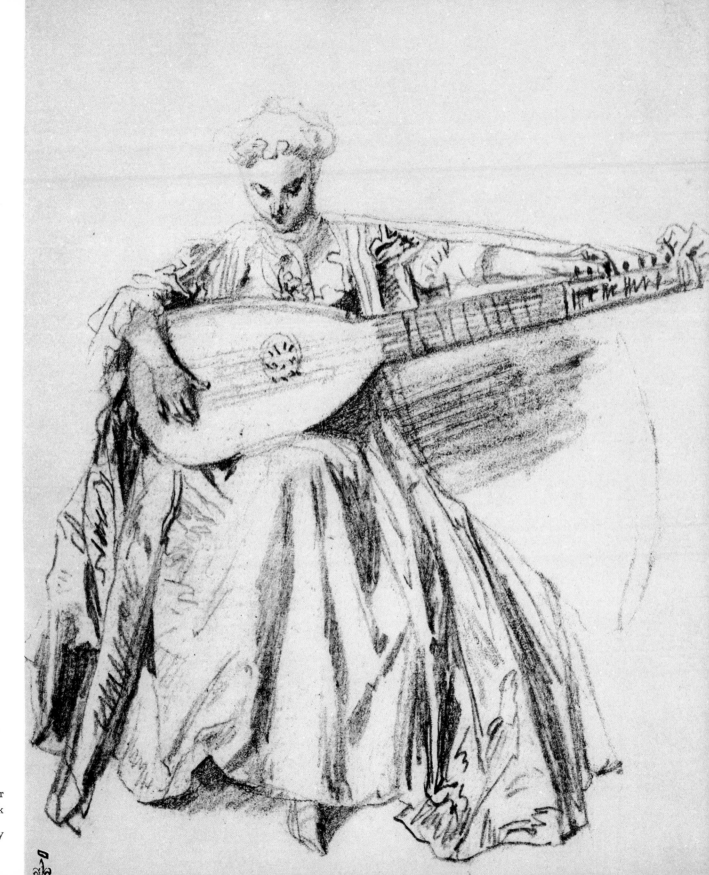

35. Lute player
Lead pencil and red chalk

Musée Condé, Chantilly

Imprecision and Music

The universe of Watteau portrays his inmost being, and at the same time reflects the mutation taking place in contemporary art, which resulted in the birth of a new age. His love of the fugitive, the immaterial, the vague were part of a universal protection against the self-assured authority of the seventeenth century. Man, like a pendulum, oscillates from one position to the opposite. His eye produces the complement of the color he stares at. At one moment he dreams of bending the world to his will and halting its unpredictable flight: he imposes on it a fixed and ideal appearance, in accordance with his mind's most enduring laws. He freezes it into an order, identifies it with an eternal and perfect model, and forbids it to change, or, in other words, to deteriorate. Such is classicism.

But scarcely has he done this than he tires and grows afraid of the very immobility he has created. He longs to regain all that he has condemned: all that changes and evolves, all that eludes the trap of demonstration and definition. He returns to time and its passing, to sensibility and the indefinable. This is the revenge of the baroque: the torrent that was frozen for a moment becomes a fixed flood once more, and the ice breaks up in turbulent splendor.

Watteau was the champion of this revenge: he came at the end of the attack launched by the Rubenists. In advocating the superiority of color over design, they paved the way for the future triumph of the fugitive over the fixed. Classicists preferred form because it seems more real and immutable. What they held against color was that it "represents only the accidental." According to the same argument, thought is more noble because it is more stable than sensibility, which is shifting and elusive. Likewise, demonstration is superior to suggestion. Thus, Watteau was for color, sensibility and suggestion—for the fugitive against the fixed. He was an excellent draftsman, but not in the classical sense. He used line not to define the permanent structure of form, but to seize on the wing that which struck him most in passing, the appearance that made an impression on his sensibility. Even his drawing aspired toward color: from the abstraction of black and white he quickly went on to red chalk and to combinations of two or three different materials. He made a beginning with pastel and water color. In his paintings he took even greater liberties: forms are no longer defined by line, nor their surfaces by modelled tonalities. He made color leap forth from shadow. He modulated color with a hundred nuances and broke it up with a thousand gleams and shimmerings. And there is always shadow, transparent or deep, to engulf what remains of the forms.

If the painting is too lively and sparkling in appearance to yield to external laws, can the spirit find in the composition an internal satisfaction for its needs of balance and stability? But like the figures themselves,

the overall composition seems to abhor any principle of stability. The figures refute it by their movements, their bowings and twisting and the composition, by its asymmetry. Sometimes the composition does seem to fall into the trap of tradition and to organize itself around a center of interest. But if the subject is a single figure, his pointed toe will give him a narrow and unstable base. If there are groups of figures, the main one will suggest an axis that is echoed by a tree, a vase, or a statue. In both cases the rest of the picture is arranged in two circles in which the background makes two openings. But the vertical, which inevitably evokes the idea of center and symmetry, at once denies the expected by an "odd" displacement that does not correspond to any constant or measurable proportion. Watteau's most characteristic composition is even farther from the traditional type. As we have seen, it is no longer a balanced organization of lines and masses but a movement that wavers across the picture and draws the eye after it.

At least the picture perhaps offers some logical development of action. But with Watteau, action escapes definition just as completely as form escapes fixity of outline. It has already been shown that in his work action is no longer intelligible or explicable by reason, as it was with Poussin and Le Brun. It is nowhere and everywhere. It addresses itself and reveals itself only to the sensibility. Long before Verlaine, it is *"la chose envolée qu'on sent qui fuit d'une âme en allée"* ("The vanished something one senses fleeing from a soul in flight").

It is music, the realm of the immaterial, the elusive, the shifting. Just as a classicist like Poussin felt a kinship with architecture—the domain of what can be seen and weighed, understood and ordered, and what is frozen into immutable perfection—so Watteau belonged to the family of music, of strings that vibrate and make the soul tremble in strange and secret unison. Here again, he prepared the way for the Symbolists and their denial of the nineteenth century's overly rational positivism. Verlaine asks:

> *De la musique avant toute chose*
> *Et pour cela préfère l'Impair*
> *Plus vague et plus soluble dans l'air*
> *De la musique encore et toujours!*
> (Music, above all
> And for that prefers what is irregular
> Vaguer and more soluble in air
>
> Music again and forever.)

Watteau never ceased to invoke music in his work and art. "He was a fine and subtle judge of music," Caylus wrote. Jullienne, in the engraving of him with his friend, plays the cello "under the singing boughs" while Watteau listens, brush suspended. He must have listened this way at Crozat's; at the concerts in the rue Richelieu where Mademoiselle Dargenon, La Fosse's niece, used to sing; on summer evenings on the lawns at Montmorency; and at the house of his friend Sirois, whom he showed playing the guitar in *Les Habits sont italiens* (The Clothes are italian).

All his work vibrates with music. His painting would be more silent if *Mezzetin* in solitude with his head thrown back in inspiration, did not lift his voice up almost in pain as he accompanies himself on the guitar; if *La Finette* (The Artful One), *L'Enchanteur* (The Magician), and the *Donneur de sérénades* (The Serenader) of Chantilly did not play; if his bagpipers and fiddlers did not lead the dance; and if his lovers did not sometimes prefer musical harmonies to whispered confidence.

Once again Watteau finds his ancestry: he takes his place in the line of painters who since the Venetians, since Bellini and Giorgione, have rendered the secret melody of the soul of the pictures. He goes back to Le Nain with his love of young shepherds piping, and he precedes Corot with his evocation of women's slender hands playing the mandolins. Music links him also with Vermeer: one is the poet of the clear ring of crystal, the other of airs half-heard. Both use in their paintings the same bass viols with poised bows: in Vermeer the pause is only the hush of silence and immobility, in Watteau it embraces fleeting time.

In this way, Watteau best evokes time and its apprehension, which are so vital to his art. In music, time takes the place of space and matter. Whenever music is evoked, so is time. Vermeer halts time, and suspends it on a chord. Watteau, on the contrary, exalts it and, just as his meandering procession of figures leads us toward the gate of the horizon, so the music also wavers, hastening

> . . . *les instants sereins*
> *Qui m'ont conduit et t'ont conduite,*
> *Mélancoliques pèlerins,*
> *Jusqu'à cette heure dont la fuite*
> *Tournoie au son des tambourins.*

> (. . . those serene moments
> Which have brought me, and have brought thee,
> Melancholy pilgrims,
> To this present hour, whose flight
> Twirls to the sound of tambourines.)

36. Study for "Le Concert champêtre"
Red and black chalks
British Museum, London

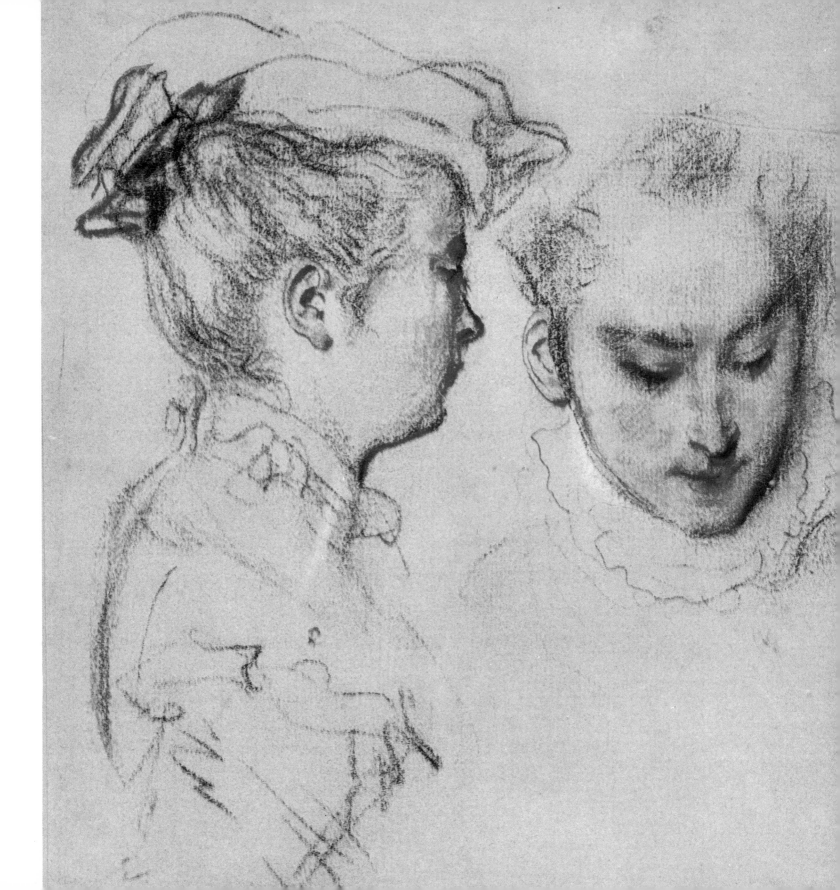

From the Real to the Imaginary

Thus Watteau worked and constructed his universe at the point where the urgings of his time and the desires of his own sensibility met. But what was that universe made of? Imagination? He did not possess the type of creative force whose heat can melt the world and reshape it to its will. For that, the effervescence of a Rubens is needed. Nor do we find reality in Watteau. The mirror oh his painting is too blurred to reflect exactly what already exists. It is the fate of his vague and disturbing art to be always midway: midway, as we have seen, between desire and regret, between the slowness of dream and the swiftness of execution, and, with the same ambiguity, midway between fact and fiction.

Perhaps it is this that makes Watteau so fundamentally French. He is just as incapable of total and startling re-creation as of passive and scrupulous imitation. He does not throw us into a hallucinatory unknown, like Rembrandt or Goya. He does not lead us back into the known, like Van Eyck or Hobbema. Once again he must be placed in the line that runs from Le Nain to Chardin and, beyond, to Corot: a tradition in which truth replaces exactitude and reverie, invention—the tradition of poetic realism.

France has a sort of atavistic positivism, probably of rural origin. It is the product of a too perfect harmony between man and nature, which prevents her from producing daring visionaries. Yet she cherishes humane values too much ever to conceive of a total surrender to material things. Between men and men's powers, nature and objectivity, there is no opposition, nor even a distinction. Man cannot separate nature itself from the vibrations and echoes nature sets up within him. He neither wishes for nor can imagine anything to take nature's place. The bond between them is inseparable from that happiness called poetry. It is nothing, then, except reality, but a reality that wears the face of our love for it. From this concept is born poetic realism, in which truth is never reduced to strict exactitude but poetry never goes so far as to become illusion.

Watteau united a Northern origin that made him intensely suited to perceive and capture, with a nervous and delicate temperament that easily converted any fact into the infinite vibrations of a dream. He extended the possibilities of this duality as far as possible. Reality and dream—Théophile Gauthier spoke of "the reality of dream" and Jean-Louis Vaudoyer, writing of Watteau, spoke of "the dream of reality."

By race, talent, and discipline, Watteau was a realist at the beginning. Afterwards, he began to voyage toward such a distant harbor that some have denied him that title. The paradox is only an apparent one. One side of his art is oriented toward the observation of the external world, of popular and even bourgeois

subjects, such as *L'Occupation selon l'âge.* It was this commanding consciousness of the real that protected him against academic convention when he arrived in Paris, and drew him back to Valenciennes and military scenes—a kind of pictorial reporting—when the opposite, modern conventions of Gillot and Audran threatened to attract him. He always appealed to nature as his school and lawgiver. As a child he had sketched charlatans in the marketplace. Already he had found his vocation in reproducing the mixture of true spectacle and mirage, the imaginary world of the stage. While in Paris he used to go out in the streets to sustain his interest in observation, and back in Valenciennes he took notes on military and popular types. He always had his sketchbook with him and he drew everything he saw with the sole object of recording it, without thinking of what use he might make of it later. Caylus has told us, "It was his custom to draw his studies in a bound volume so that he might always have a number of them at hand." Posterity has narrowed the scope of his work so that the *fêtes galantes*, by which contemporary amateurs once classified him, have come to dominate the rest. But in an impartial collection such as Jullienne's there were landscapes and scenes of suburban pleasure gardens and watering places. Jullienne wrote that he was "a great admirer of nature and all the masters who copied her," and Nature always afforded him protection against his own excesses. She was always the ground under his feet, where he might find stability, and impetus.

But reality did not completely satisfy Watteau. Although he never departed from it, he tried to renew its appearance, adapt it to his desires, make it conform to the dream to which he saw it aspire. To do this, he still did not imagine but resorted to dressing up reality. Caylus wrote, "he had a collection of fancy costumes, some of them theatrical, in which he dressed characters of both sexes, when he found willing ones, to be depicted in the attitudes *that nature presented*, the less studied the better."

His men always wore costumes with doublets and collarettes, in which conventions of the theater mingled with memories of the reign of Louis XIII. In early works, such as the *Saisons Jullienne*, the women wore costumes of the time of Marie de' Medici, sometimes even caps dating back to Henry III. Gradually they came to be dressed in contemporary style. Were not women, after all, a natural mirage and born actresses in the theater of life?

With Watteau there appeared an imaginary world which could superimpose itself on the actual one without ceasing to draw its components from it. "When he felt like painting a picture, he went to his album and chose from it the figures he needed." The figures were still linked to the reality from which they had been taken,

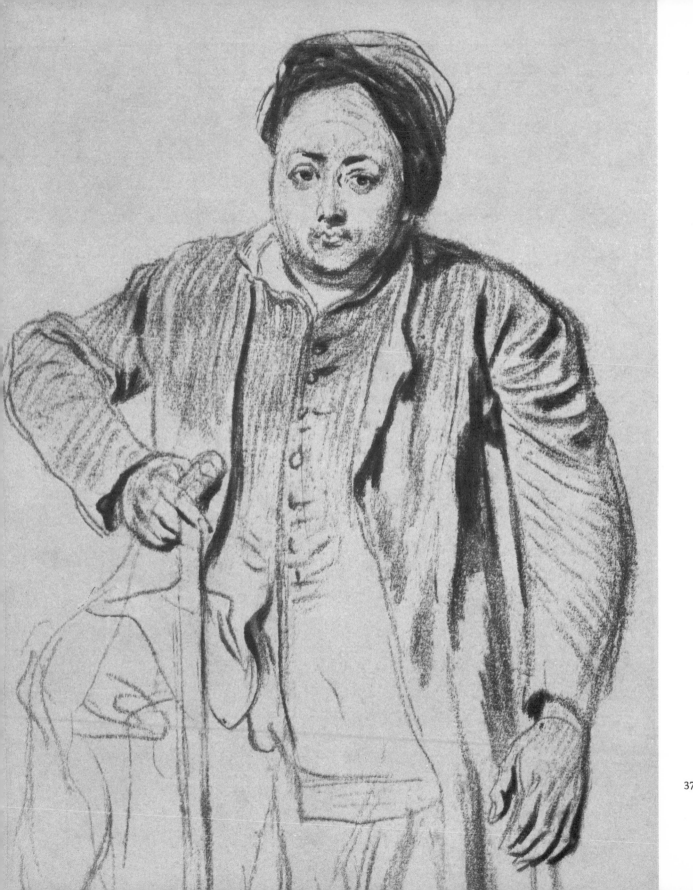

37. Portrait of Antoine de La Ro
in red chalk

Fitzwilliam Museum,
Cambridge

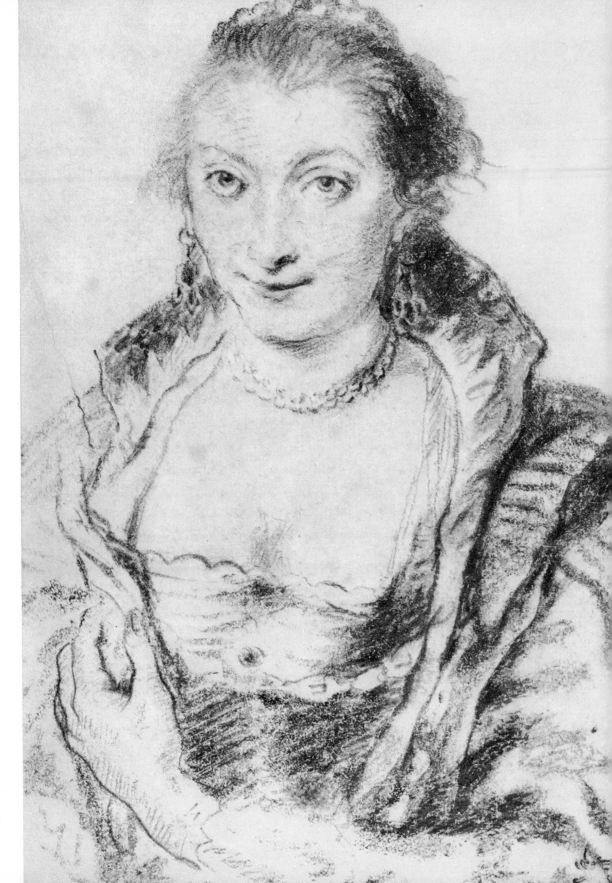

38. Portrait of Isabelle Brandt
after Rubens

Black, red and white chalks
Fitzwilliam Museum, Cambridge

but he would govern them as he wished in his kingdom of fancy. First he needed a setting, which he chose from nature, a nature reconstituted so as to please himself, clad in the stuff of his dreams and decanted through the filter of his memory. His work has as many "memories" of the Luxembourg or Montmorency as Corot's has "souvenirs" of Mortefontaine. Ballot de Sovot recounts how Watteau advised Nicolas Lancret to go "to the master of masters, Nature," saying that "he himself had done so and been all the better for it." Here, he revealed his own method: to draw a few landscapes on the outskirts of Paris, go somewhere else and sketch the figures, and then combine them "to form a picture out of his imagination and choice."

Each element was authentic, and, in his drawings, Watteau established its truth. The imaginary came into being with a free combination of these elements: assured that they were based on reality, he could give free rein to reverie. Nothing could be more different from the visionary who substitutes himself for what is. Watteau did not invent: he played with the cards he was given, but he shuffled them so as to produce dazzlingly new results. His faithfulness to the model was confined to taking a real figure from his album. It has been noticed that his groups of two are usually arbitrary, the result of bringing together two independent drawings.

It is exceptional for a couple in one of his paintings to have been previously paired together. But he took no liberty with his originals other than putting them together in one picture. He was so averse to changing them that he often extended his repertoire by simply reversing a figure. While he was faithful to reality, poetry also called him, and, divided between the two, he settled for transposition. For example, a drawing once in the Dormeuil collection showed two studies of a servant girl. On the right she was putting on a stocking; but what was she doing on the left? Perhaps her outstretched arms and nimble hands were spreading clothes out to dry. Watteau transposed her in both the *Leçon d'Amour* (A Lesson in Love) and the *Réunion champêtre*, or *Réunion en plein air* (Rural Gathering). Nothing was changed—except that now she was gathering roses.

Reality, choice, imagination—each developed out of the one before, none could be omitted. Watteau never transgressed these limits. He made use of a progressive filtering, so that what Nature supplied and what he looked for there mingled in a subtle alchemy, producing the imaginary out of the real, like perfume out of the distillation of flowers.

He did not oppose reality: he entered into association with it, and even seemed to obey it, so it would adapt better to his game. His work was a kind of play. A child, too weak to act on the world and bend it to his

80

will, borrows elements from it in the form of dolls or tin soldiers. He takes the world's fixed and ordered gestures and transports them into a more or less fanciful setting where he is master. He can arrange, combine, and direct these extracts from reality according to his fancy, which comes to life through them. There is no essential difference between this and the artist's dream fed solely on scraps of experience, residues supplied by the memory but chosen and selected, then launched on the inner currents of hopes and obsessions, where they whirl and mingle in obedience to subconscious imperatives. Watteau played this game even in the details of execution. When he began a painting, he had not yet established the composition in his mind. He had the setting ready—landscape, or sometimes, architecture—and in this he would place and group the characters taken from his album, like puppets taken out of their box. But as he painted, he prolonged the pleasure by modifying or rearranging a head or a leg. He would change a minor figure, sometimes a whole group. In *Les Plaisirs du Bal* he even reconstructed the entire setting. The painting, like a dream, was never finished: it evolved and was transformed like a cloud by the wind, until that moment when Watteau reluctantly abandoned the little universe that lived for awhile beneath his brush.

Watteau makes us think of the theater even more than of play or dream. It is significant that he was under its spell. What do people seek in the theater but a spectacle at once real, because it is seen and made up of the acts and words of living beings, and unreal, because it is based on illusion and obeys the laws of the imagination? Later another painter who was scrupulous about the truth, wishing not to transgress but longing to transfigure it, to escape but not deny it, would also see the theater as the equivalent of the difficult art of realistic fancy, and authentic artifice. This was Degas. Yet it recalls all French painting, since that is its dilemma: poetry and reality. No other school has had so enduring and so great a love for the theater.

To escape from reality into another reality close at hand, to find a gateway into dream, to delight in a mirage that is at the same time a real lake—this is the solution of poetic realism. It was revealed to Watteau when he was a child. Gersaint wrote, "He made use of his free moments to go and draw from life the various dramatic performances that travelling quacks and charlatans used to put on." The man he accompanied to Paris was a scene painter at the Opera. His master, Gillot, was a painter of the commedia dell'arte. From that time on, Watteau took his characters and situations from either the French or Italian players. The models he used in his studio were often actors whom he would dress in theatrical costume. His subjects often had their source in the theater: it has been shown that *L'Embarquement pour l'Ile de Cythère* was originally inspired by a song in Dancourt's comedy *Les Trois Cousines*.

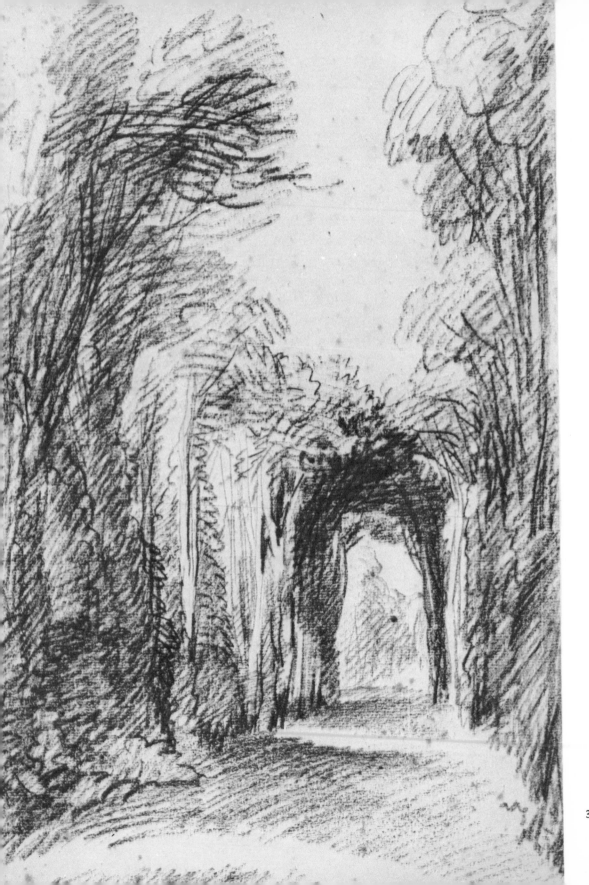

39. Avenue of trees in red chalk
Private collection

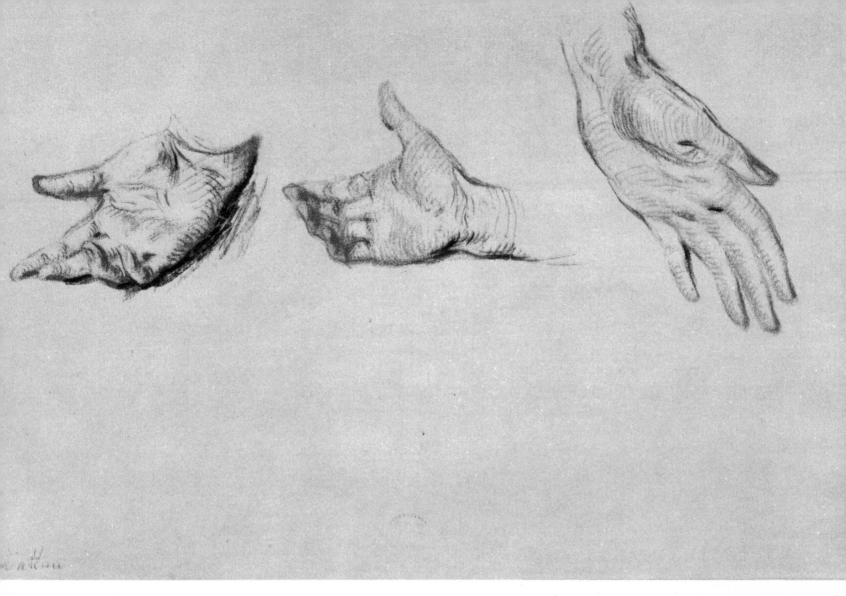

40. Study of hands
 Lead pencil, black and red chalks

 British Museum, London

Such is the universe of Watteau—hardly imaginary, only a little imaginative, akin to that of play, dream, or the theater. Realistic points of departure are given new value by the meaning which is attached to them, and for which they become the support and symbol. In this way, one may cross over into poetry. For the ordinary man, all living things and all objects, apart from their practical application, are more or less commonplace and equivalent. The poet singles out those which, because of the affinity he feels for them, may serve as signs for his sensibility. The more restricted the number of elements that goes to make up the elective universe, the more intense and specific that universe will be. Thus, Watteau proceeded to polarize certain figures, certain gestures—the quintessence of attitudes. He drew them so as to make them his own and reduce them to those elements that appealed to him, and in this way he collected a sort of herbarium through which he could wander at will. From the plants kept there he composed new nosegays. He never tired of rearranging the permanent elements which, by both their choice and arrangement, reveal the aspirations of his soul.

He held a mirror up to his soul, until then invisible and unknown to all but himself, where others could see a face to observe, question, and love. The mirror revealed a ballet of shadows. From these imaginary figures locked into poses, a silent life emanated and gradually breathed movement into them. Soon a murmur began, the hint of a caress, the suggestion of a kiss. To a faint sound of music, a gentle dance began. The universe of Watteau started to move. The action was vague yet full of meaning, because it incarnated all of Watteau, not just as he was, but also as he had been at every stage in his life. Despite the brevity of his life, Watteau, like everyone, encountered difficulties that grew and were resolved, and he went through different phases in pursuit of his fulfillment. He was sensitive, nervous, changeable, passionate, and reserved. Gersaint wrote, "His character was restless and headstrong," and Caylus stressed a "certain spirit in instability that dominated him." But what do we really know about his inner life, except that it must have beeen troubled and turbulent? History tells us practically nothing. Although anecdote is lacking, we can trace his brief destiny in the reflection of himself that is seen in his work.

III

The World of the Imagination
Its evolution

While the work an artist leaves is immutable, definitive, and fixed forever, the artist is variable, sometimes contradictory, obedient to the pattern of his destiny. This is too often forgotten. Nothing should be asserted about an artist or his work except in terms of his evolution as a whole. Sometimes he matures steadily, even to the point of sclerosis; sometimes he alters so much he may seem to deny himself. It is true that a human being possesses, as such, an essential unity. But this unity is always in action and so always changing. An artist sets down his nature in each of his works—but his nature only at a particular moment. No valid conclusion can be drawn about the works as a whole unless their chronology has been established.

The chronology of Watteau's work is particularly elusive. As in the case of Vermeer, very few of the pictures are dated and historical evidence is limited. The chronology can be arrived at only through the development of style as revealed through forms and techniques. The results of such a study would be too lengthy to set down here.

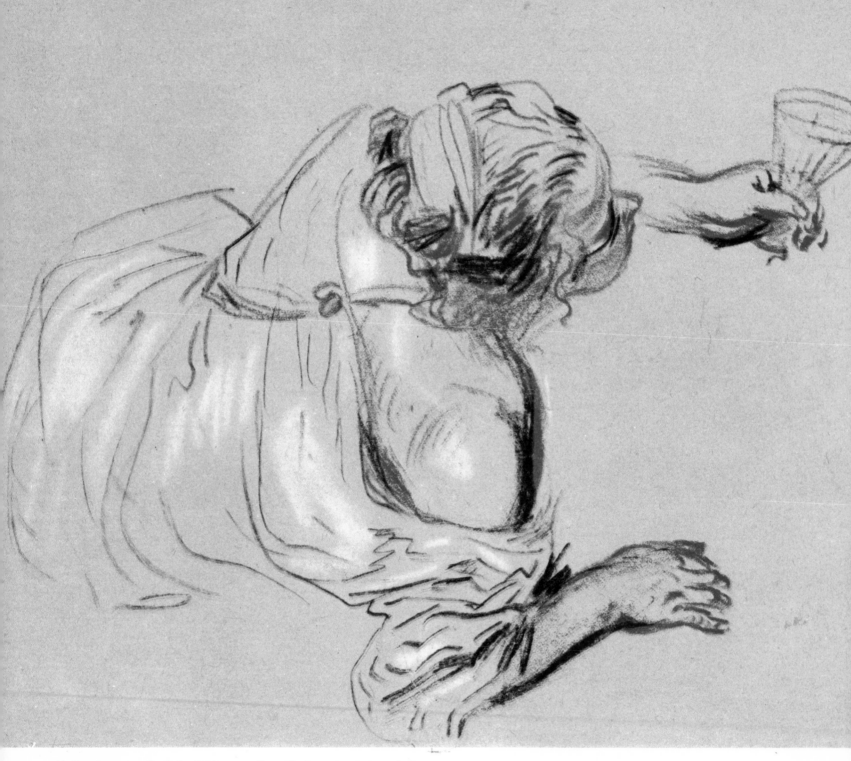

41.Bacchante Study for "L'Automne" Black, red and white chalks
Musée Cognacq-Jay, Paris

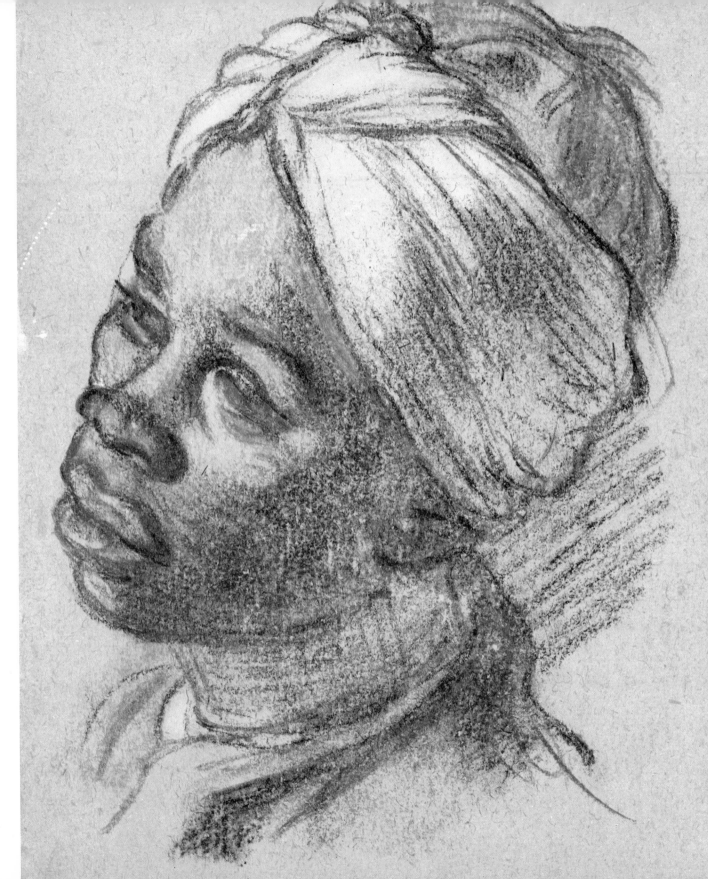

42
Study of a young Negro
British Museum, London

In Search of the Self

Even in the first phase of his career, when he sought and formed himself through example and instruction, Watteau revealed his natural inclinations by the choices he made. He did not yet know how he would eventually use all that he retained and stored up, but his instinct did not deceive him. Gillot's actors or Audran's shepherds and shepherdesses brought to him that mingling of love and make-believe from which his poetry would be distilled. He was still feeling his way; the moment he left Paris to find himself again in his native country, he went farthest away from what he later became. He never returned to the picturesque realism of those military scenes, but studied closely, they showed tendencies that were to become familiar. There are few pictures of camps, departures, or returns of troops, that do not contain a note of gallantry or a glimpse of a charming face. The beggars and wanderers are always accompanied by the peasant women who received Watteau's special attention. Though they may still be dressed in thick skirts, the girls spinning *(Fileuse)* and the village maidens *(Villageoise)* paddling in the river and wringing out their dresses already have appealing little faces and seem to have attracted Watteau's special attention—so much so that he even introduced a similar figure into one of his elaborate decorations.

At this time Watteau's innate refinement was beginning to show and to recoil from the vulgarities which at first he had taken over from tradition. He was now twenty-two or twenty-three. The man he was to become was asserting himself in his being and in his art. He was aware enough of himself to project himself into his characters and to make them conform to his own image. He gave his soldiers, modest as they were, his own proportions—the tall builds, slender hands, and thin legs always crossed with such proud distinction. They have a striking, youthful elegance which Watteau achieved more appropriately at about the same time (1710), in his drawings and engravings for the *Figures de modes* (Figures of Fashion). Here he introduced his future characters. The nonchalant fellow leaning on his elbow or standing upright is Watteau himself or his double. The slim youth who looks at us with his head to one side and his knee bent is brother to the one who sits and paints with Julienne in *Assis auprès de toy* . . . (Sitting beside you . . .), or to the Watteau that Boucher represented. The woman is already the woman of the *Fêtes galantes* and the *Embarquement pour l'Ile de Cythère*. The *Villageoise* resembled her except for the finery. Now she has risen into society and, fan in hand, is about to utter some elegant remark. She even tries on her cloak, and already she has the trick of nibbling irresolutely at the fan that will flutter in time to her hesitations when she appears on the brink of the *Embarquement*. All around, the façades of town houses mingle with tall trees and stone fountains. The *Figures de différents caractères* (Different Personalities) leave out only one theme: the beggars of the early

work are scarcely touched on. But the sprightly *Polonaise* is not far from *La Finette* and her friend *L'Indifférent (Fig. 32)*. The actors are getting ready to begin.

The transition from realistic observation to amorous fantasy took place imperceptibly during the visit to Valenciennes. Watteau began by painting the then familiar spectacles of Northern life, such as the armies of Oudenarde and Malplaquet. In a diptych of war and peace that contrasted vigorous military episodes with more restful feminine ones, it was only natural to show village life and amusements as a counterpart to military life. Watteau, who had singled out "gallant" aspects in the latter, could not fail to find them in the former. Betrothals, weddings, dancing parties with a couple seen in the midst of gaiety, were now added to his range of amorous subjects. As did Teniers or Rubens, he sometimes showed the lord of the manor condescending to watch the revelry. Although still Northern in influence, these scenes provided Watteau with a factual counterpart to the seventeenth century pastoral tradition which he knew through Audran. Watteau's paintings of *contrats de mariage* (marriage contracts), *accordées* (betrothals), and *noces de village* (village weddings) are related in theme to the peasant subjects of Le Nain, but turn the tradition in the direction of the future shepherds and shepherdesses at Trianon. For the moment, Watteau stood exactly midway between the two both in time and spirit.

Meanwhile the setting was emerging more clearly. It would be naive to think of the periods as separate and successive phases, like chapters in a book: military scenes, rustic scenes, and *fêtes galantes*. While each series is prevalent at different times, they also stretch out to overlap with others and to evolve parallel to them. The later military scenes show a development in the natural setting which corresponds with that used for the *contrats de mariage* and the *accordées de village*. After the *Départ des conscrits* (Departure of the Conscripts), which was done without a specific model, the landscape acquired greater stability and strength. In the *Camp volant* (The Flying Column), the vertical is formed by a clump of trees near the middle of the picture, and the scene itself is disposed in two wreaths, one on either side. The *Fatigues de la guerre* introduces a new technique of lighting: breaks in the clouds cast patches of brightness on storm-ravaged trees, farmhouses, and furrowed earth. In a composition crowded with figures, one's attention is skillfully divided by alternating light and shadow. Here the storm provides a sufficient pretext, but in the rural scenes the alternation of light and shade is purely arbitrary. Watteau is bold enough to rise above the real and make it yield to his fancy. Once again the North gave him an example. He might have learned from Rembrandt's landscapes how to abandon himself to the wavering complexities of nature and the dim mystery of shadow, yet direct

the spectator's attention by sudden gleams of light. In *La Cascade* (The Waterfall) he exploited the accented and unaccented beats of light to illuminate a building on the horizon, or a jet of water and its spray.

A good deal of this technique is artifice, but through it Watteau was learning how to organize compositions in which man and landscape are fused together. At the same time there appeared and unreal, unifying quality that helped him cross the threshold into imagination. In *L'Accordée de village* groups of figures are seen in and out of the shadow, and the distance can be seen burning like a flame through a veil of swirling smoke. From now on, Watteau was master of his setting and was able to unify it at the same time that he increased its complexity. He did so by means of a collective atmosphere in which figures and setting converged, and he used the resulting unity to suggest an unknown world that awakens reverie.

It now remained for Watteau to give this world a meaning—the meaning of his own sensibility.

As an almost imperceptible current may appear in what seems still water, scarcely stirring a few weeds, then becoming stronger until it carries everything along with it, so a theme makes its appearance adventitiously in the military scenes. It becomes the main pretext, though still only a pretext, in the rural pictures. This theme is love. The peasants become shepherds and the shepherds, imaginary gallants like those in the theater or the novels of times gone by. The illusion is fostered by the Rembrandt-like light of dream that is swift to deepen, swift to lighten. Watteau is already midway between the reality from which he comes and the world of fantasy where he is headed and where the elsewhere and the long ago prevail. The *Promenade sur les remparts* (Stroll on the Ramparts) and the *Jardins de Saint-Cloud* take us there. The figures, no more real than their settings, come from the *Figures de mode* and wear the costumes of the theater or the Pays du Tendre. Watteau gives them the touch of sophistication and the graceful proportions that belong to the world of elegance and artifice. Even their faces are conventionally vague and babylike, those of charming marionettes.

The universe of Watteau had been born. Many of its details were still to be developed and defined, but now everything was ready for the prologue. *La Finette* and *L'Indifférent*, brilliant yet slightly empty, would serve as godparents. Behind them a misty light, falling through swirls of golden smoke or layers of iridescent color, would form a background as enchanting and chimerical as they themselves. Turn them to face one another and they are *L'Enchanteur* (The Enchanter) and *L'Aventurière* (The Adventuress). Everything is in readiness for the plot, which will catch them up to the sound of mandolins and display before Watteau's eyes, as before our own, the complex intertwinings of his feelings.

43. Study in red chalk
Musée Condé, Chantilly

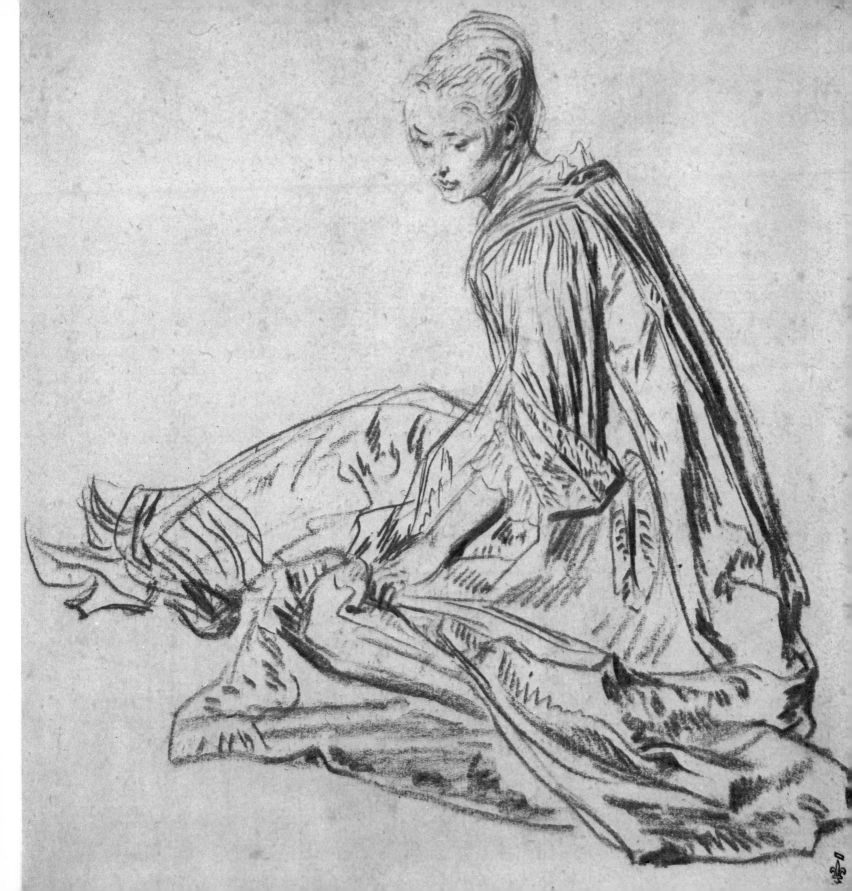

Prelude

The couple part and come forward. They were brought together by the dance, but in the *Contrat de mariage* were scarcely distinguishable from the rest of the swirling crowd. In *Le Plaisir pastoral* (Rural Pleasure), however, they form the foreground and center of interest, although the musicians still surround them like Teniers' *magots* and in the background, the village steeple out of the *Montreur de marmotte* (The Man with the Marmot) can still be seen. But the dancer is already dressed in silk and satin, and passes gradually from the rustic world into society. Soon the spark that will awaken him to the life of feeling, and change these charming puppets into souls, will be kindled: the spark of love. To get away alone, they will seek some pretext taken from Audran, such as a pretty swing; they will stray through woods and by fountains. Soon they will embrace. And the nonchalant dreamer, who lay on his back smoking and snoozing in the military scenes, begins to watch them closely.

It was probably at the moment when the action in Watteau's work began increasingly to require actors for its interpretation that the courtly shepherds changed into stage characters, and the crowds became small groups. At the same time there appeared a quality which the nineteenth century would call melancholy but which the eighteenth saw only as carefree pleasure. Until then, it is true, all that Watteau's people had thought of was amusement. But with the approach of love Watteau, the curious and smilling boy, became the adolescent. A whole unexpressed world seethed within him, demanding to be given shape in a universe for which he had as yet only assembled the materials.

Here we are provided with one of the few dates we have for Watteau's life. On July 11, 1712 he submitted some paintings to the Academy in the hope that they might win him access to the "great art" of Italy. Caylus wrote he showed "several pictures in his own style far superior to the one which had won him the prize"—that is, the second prize, in 1709. According to Pierre-Jean Mariette, *Les jaloux* (The Jealous Lovers) was among the paintings submitted. This dates an entire group of similar pictures which, like *Les jaloux*, are engraved in Jullienne: *Pierrot content* (Pierrot Happy), *Harlequin jaloux* (Harlequin Jealous), and *La Partie Quarrée* (Two Couples). From these it is a short step to the *Arlequin et Colombine* in the Wallace Collection, the *Sérénade italienne*, and so on. The composition follows the pattern first set down in the *Camp volant* and strengthened and developed in the *Plaisir pastoral.* A group of trees, to which a base is now added, forms the central axis, which is still more or less to one side. On either side of this vertical is an opening, each of

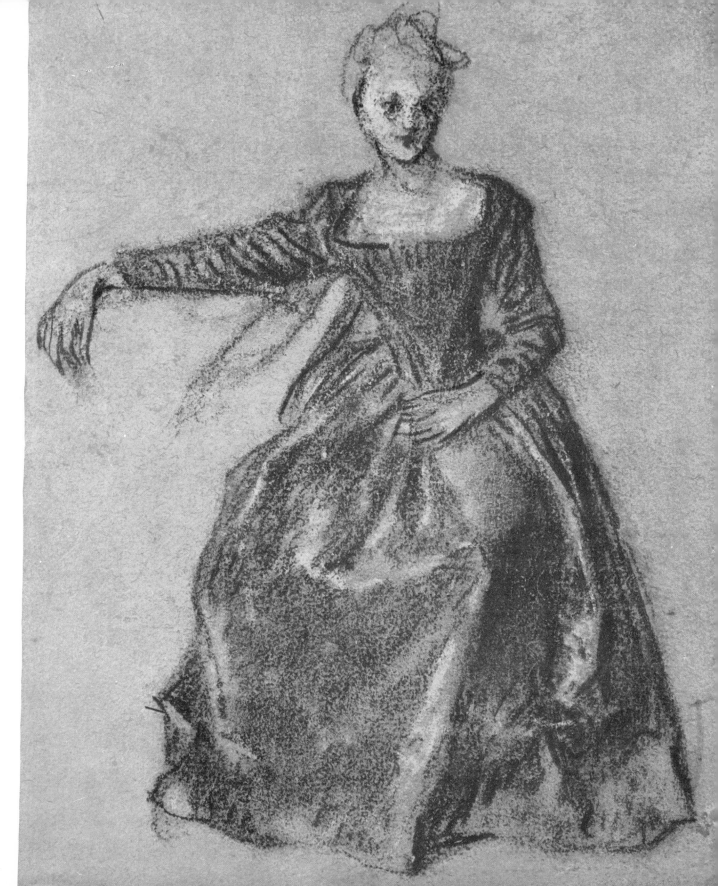

44. Study in black,
red and white chalks

British Museum, London

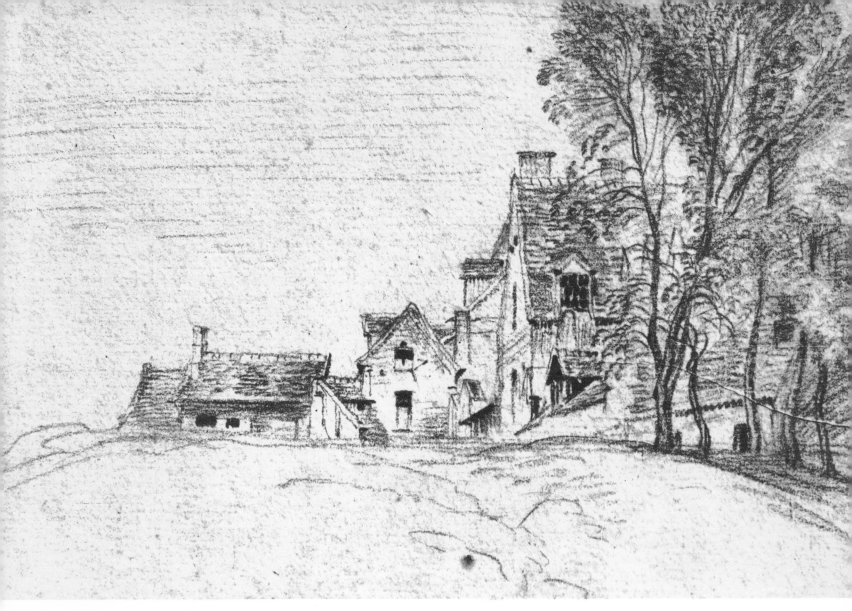

45. Study of a farm in red chalk
 Musée Bonnat, Bayonne

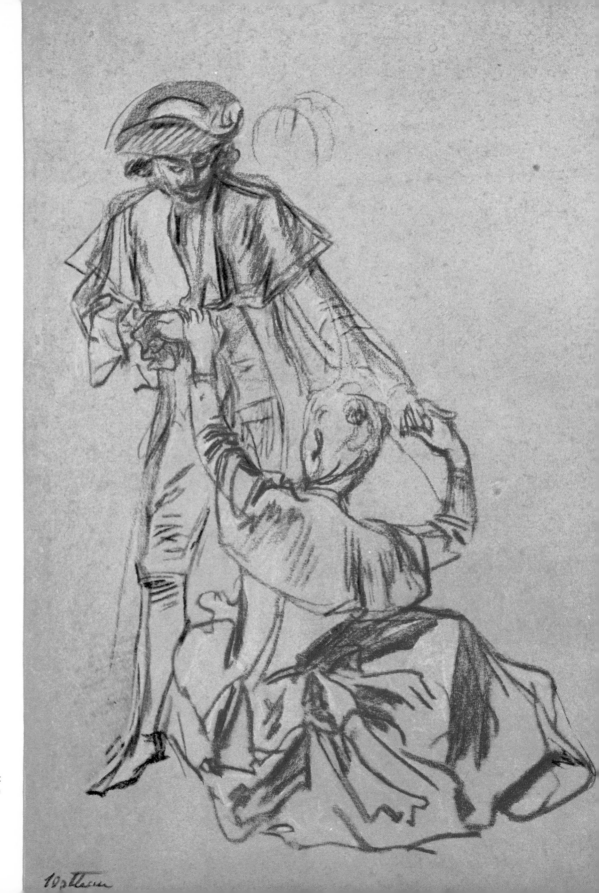

46. Study for "L'Embarquement
 pour l'Ile de Cythère"

Black, red and white chalks
British Museum, London

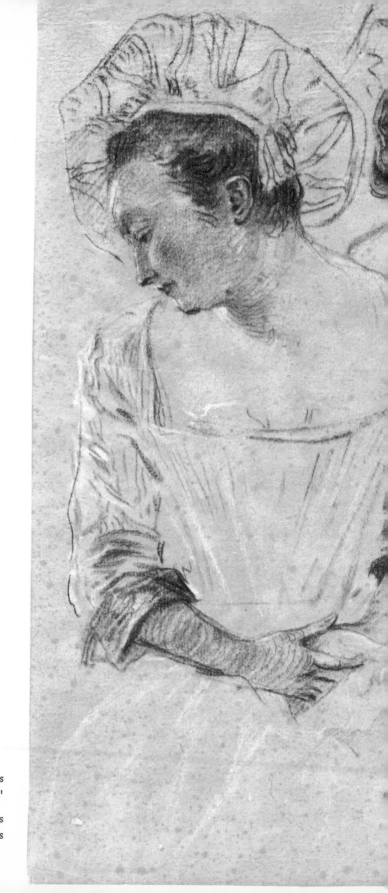

47. Studies of heads
for "La Lorgneuse", "Le Rendez-vous", and "L'Accordée de village"

Black, red and white chalks
Louvre, Paris

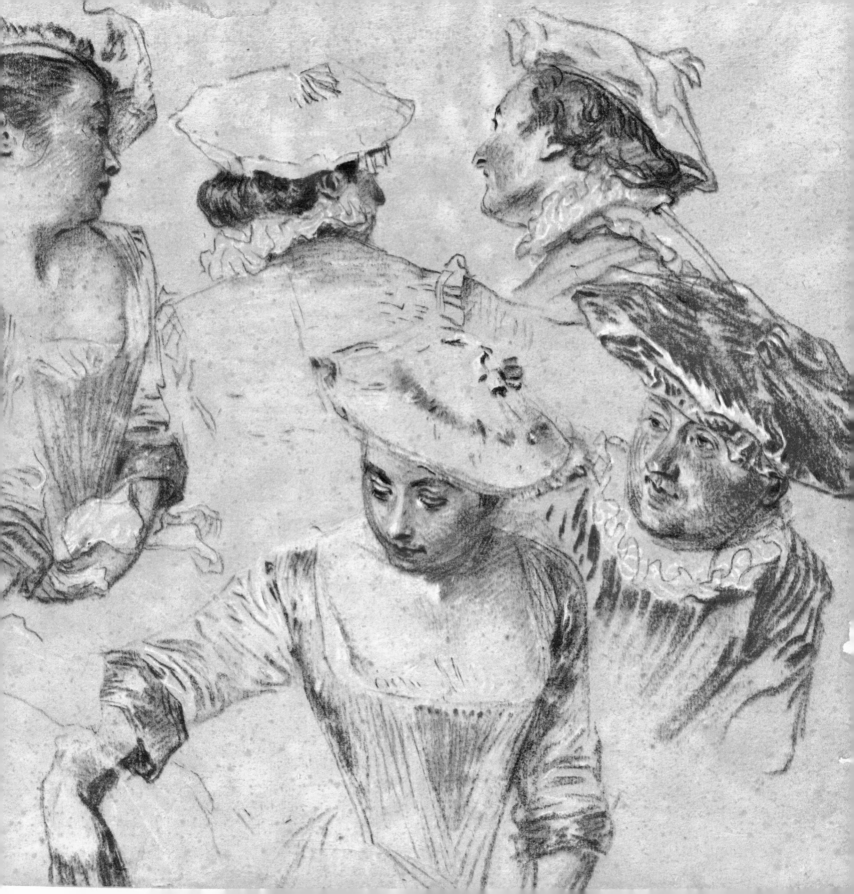

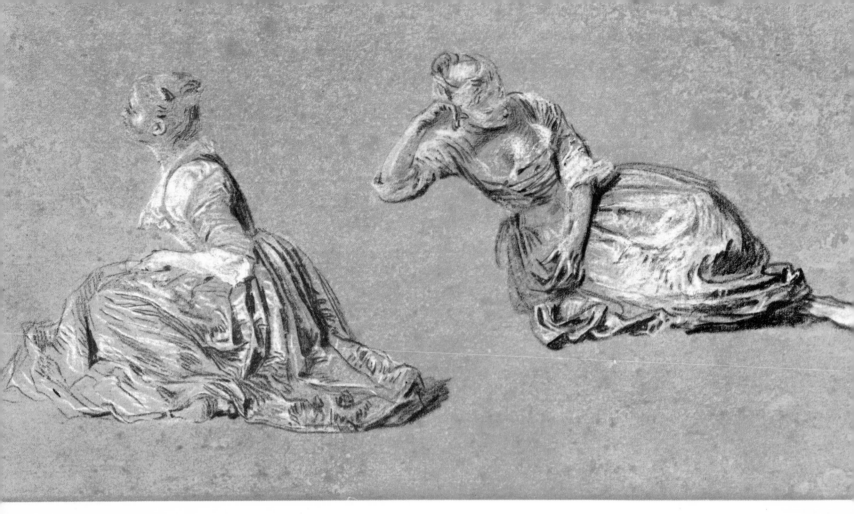

48. Study for "La Game d'Amour"
 Black, red and white chalks

 Louvre, Paris

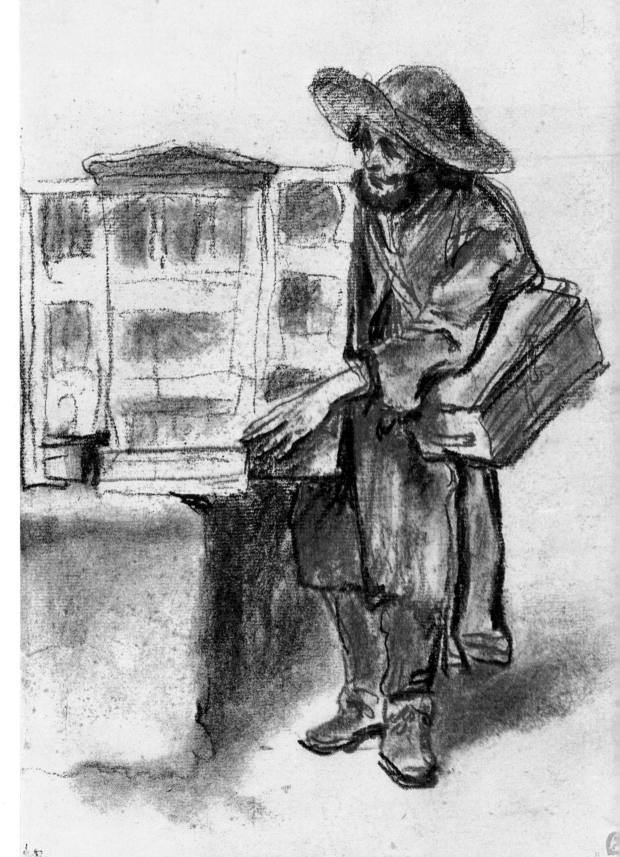

49. Study of a Savoyard
Black and red chalks

Boymans Museum, Rotterdam

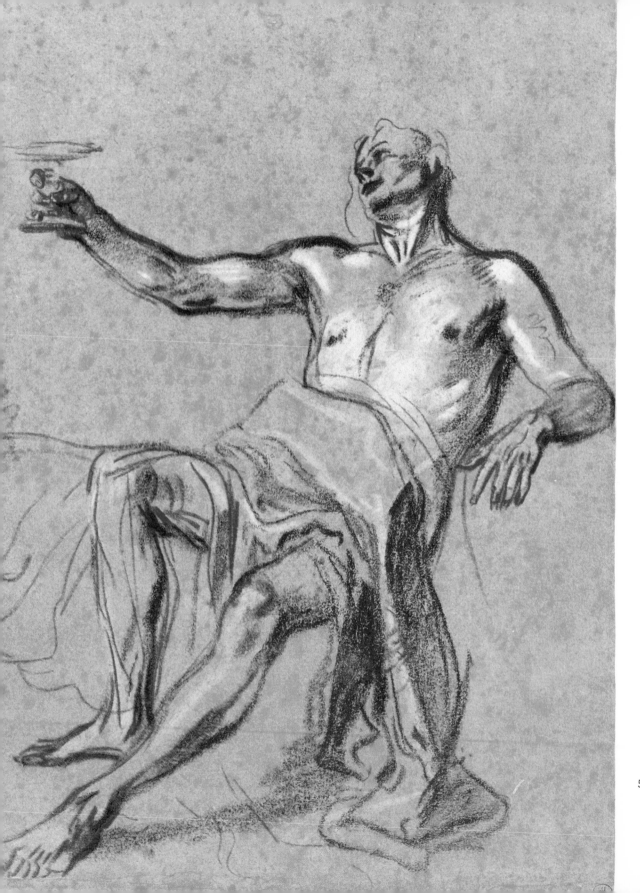

50. Bacchus
 Study for "L'Automne"

 Black, red and white chalks
 Louvre, Paris

a different size: one lets in the sky while the other, darker, opens into a cavern of foliage. Above all there is Pierrot who, seen from in front, is the artist's double. He is frank, smiling, perhaps happy: his dream has come true, and pretty girls flock around him while Harlequin hides and conceals his jealousy. The faces change, growing finer and clearer. The erstwhile dolls become sly or mocking, or listen dreamily to soulful music while Harlequin, protected by his mask, now dares to speak more boldly.

Everything was ready, the stage was set, but Watteau knew that he still lacked the indispensable complement of classical culture. That was why he asked to be sent to Rome when he presented his work. He was successful beyond his wishes, but there was no longer any question of Rome—since he was admitted as an associate member of the Academy. It was probably to make up for the disappointment that La Fosse arranged for him to have access to the Crozat collection. "He took advantage of it eagerly," we learn from Gersaint. In the months that followed, all Watteau thought of was to give his art the solid foundation of which he had dreamed for so long. The portfolios he pored over were crammed with drawings by all the great masters. "He knew no other pleasure," Gersaint continued, "than of continually examining and even copying all the pieces by the masters, and this contributed not a little to the great taste remarkable in several of his works." His sensibility and invention were also strengthened and developed by this contact from which he learned authority rather than imitation. "It was then," wrote Jullienne, "that he became entirely established in his own fine style, of which he may be said to be the inventor."

His personality was still tentatively finding its way and had only tried itself out on romantic trifles like *Les jaloux*. Through Venice Watteau discovered the fullness and intoxication of love, and the overflowing of the spirit when it is in contact with all that moves it: Woman, Nature, Music. It was Venice, too, that revealed to him the human body—the female form. He must have felt like Jupiter or Pan, whom he so often shows unveiling with passionate wonder the naked body of *Antiope (Fig. 28)* or the nymph in the *Sommeil dangereux* (Dangerous Slumber). A new world, graver and deeper, appeared, in which the nude lent its sumptuous harmonies and lifted sensual beauty to the plane of nobility and agelessness. Instead of using picturesque anecdote, Watteau could now call upon the immemorial treasures of civilization. He renounced the tumultuous, artificial lighting effects of 1710 and 1711 in favor of a pure, even light modulated only in accordance with verisimilitude. The *Fêtes au dieu Pan* (Celebrations in Honor of the God Pan) is a transposition or dream image of this liberation. Pierrot, even more cheerful than before, occupies the center of the picture,

accompanying his singing companions on the flute. His music is in harmony with that of the couple who have drawn a little apart and are exchanging meaningful glances. All around is Nature with her symphony of trees, streams, rocks, and the ancient divinities of the woods and rivers.

From now on Watteau no longer needed to search for himself. Master of his talents, he was conscious at last of his inner destiny, of the aspiration which like an appetite seeking satisfaction gave meaning to his life and work. From now on, love would be the acknowledged subject of the play for which the setting and the cast had been waiting so impatiently. What else could haunt this gentle dreamer, this delicate young man whose childhood had been unhappy and lacking in affection, whose sad heart longed for someone to lean on and trust? The theater in which his work is set is a symbolic dream reflection of a deprived existence about which we know almost nothing. In this reflection we can follow the evolution of his inner life, with all its major variations and successive attitudes. There are three different phases, distinct in themselves, but following each other like the movements of a sonata.

The prelude has just ended. The bagpipe and hurdy-gurdy have given way to wood instruments, strings, and the more resonant voice of violins. A story in pictures is about to unfold. First, desire is nourished by reverie and nostalgia—the most poetic phase, ending with the *Embarquement pour l'Ile de Cythère* in 1717. Next comes ardor, a phase when Watteau's art becomes more urgent, almost harsh with its insistent, even morbid elements of technique; this continued until the period of his departure for England in 1720. Then a more tranquil and untroubled harmony introduces a growing realism, which seems to promise quite new developments, but was cut short by his death in 1721.

What historical or biographical incidents may have paralleled all this is a question that belongs to the novelist. All we can see are the results of those incidents in shape and color, readable by unmistakable psychological signs.

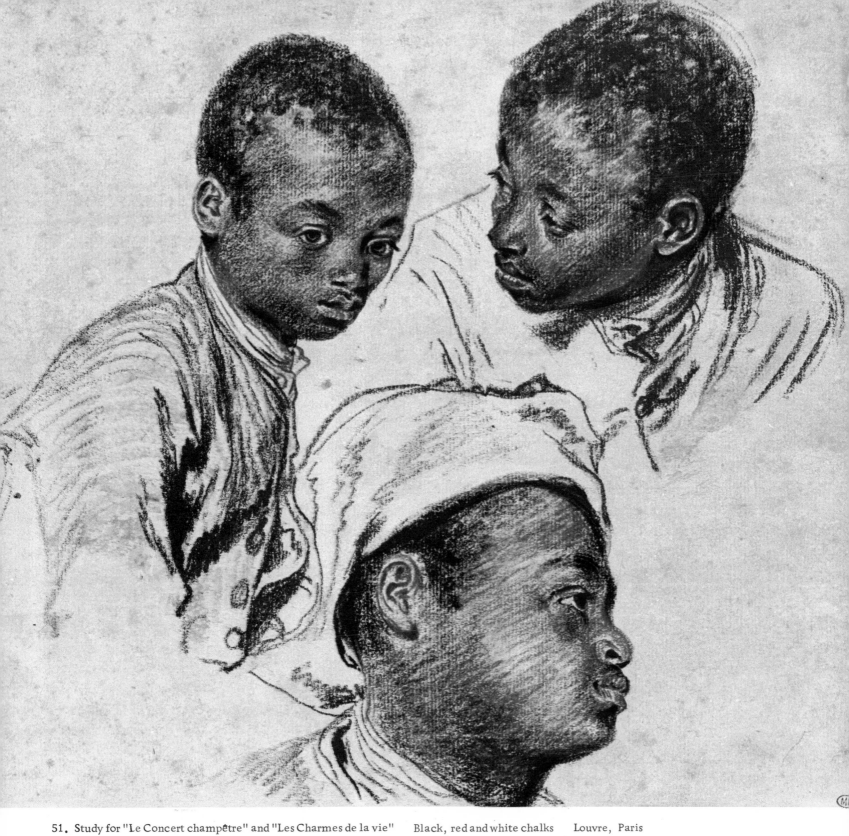

51. **Study for "Le Concert champêtre" and "Les Charmes de la vie"** Black, red and white chalks Louvre, Paris

Desire

Crozat not only made available his collection of master drawings to Watteau but also introduced the young artist to his circle. There were concerts in the rue de Richelieu, walks in the grounds at Montmorency. The Luxembourg had shown Watteau, Caylus tells us, "a fine garden, which was more thickly planted and less trim than those of other royal houses, and which offered endless different points of view." Montmorency added something else. There Nature became the extension of Woman and the sentiments she inspired. Paths opened up, inviting leisurely wanderings. There were deep woods where the silence was broken only by the sound of a fountain or a sudden tinkle of laughter; murmurs died away as soon as they were uttered. Once could glimpse the flash of a gown among the trees; at any turn one might come upon a view of the distant landscape or the beckoning sky.

For Watteau, Nature was transformed into the setting of attempted love. There, due to Crozat, he mingled with rich men, idlers, artists, beautiful women, actresses. It was a world of shepherds and shepherdesses, the pastoral novel come to life. All was in keeping with and under the sway of Woman, the queen: music, elegant conversation, languorous strolls, pleas, half-promises, murmurs, declarations.

Here, probably, Watteau had his first important emotional experiences. Here, certainly he formed his great friendships with Jullienne and Caylus. But what of love? What did he feel among all those smiling, gracious beauties who encouraged admiration and desire? They must have seemed rather distant princesses to one as shy as he, as taciturn, and as introverted. But we have no evidence about this except such pictures as *La Cascade*, of which there is a copy in the Wallace Collection in London. Above the fountain is a sculptured group by Sarrazin, *Enfants à la chèvre* (Children with a Goat), which belonged to Crozat at that time and so is a valuable indication of the place that inspired the picture. But the couple—the intent, slightly pleading man and the roguish inattentive woman—are invented; not entirely, however. There is a glimpse of a declaration in *La Conversation* that seems to be contemporary with *La Cascade:* the fine, rather stiff proportions of the figures and the noticeable absence of trimmed poplars and umbrella pines that were common in the preceding period; they indicate a date of not later than 1712 or 1713. The little Negro boy is also evidence that Watteau is still quite close to Veronese. Nor are we far away from the *Bal champêtre* (Rustic Dance) belonging to Count de Noailles. In each of these paintings, the composition consists of a couple in the middle of the picture, seen against the sky and enclosed at a distance by two unequal groups. But the *Bal*, with its "projection" lighting and umbrella pines, reminds us of the rustic period, particularly *La Musette* (The Bagpipe). The *Conversation* is a little farther from the rural scenes and brings us to the beginning of Watteau's

stay with Crozat. But in this transition we do not only go from peasants to high society, we also exchange doll figures with their fancy costumes for real people. These characters are the artist and his friends. Watteau is there and acknowledges it. He is the tall, thin young man with his head always to one side. Is it to make his intent, adoring gaze more imploring as it rests on a pretty coquette? She turns away indifferently, ignoring his gesture toward the forest, where they might whisper secrets like the lovers in the imaginary *La Cascade*. For an instant Watteau has shown us his own presence at the heart of the action. Now he can resume his work: we shall not forget his confession. The show goes on. A new scene: now it is *Les Plaisirs du Bal* *(Figs. 12, 30)*. The couple have taken up the same position and the same attitudes as in the *Bal champêtre*, but the setting and costumes have changed. A Veronese palace, italianate linear perspectives, and picturesque Negro boys attest to Watteau's classical studies. The thickly wooded park goes back to the horizon. These imaginary aristocrats with their supple, agile bodies and shimmering draperies take us into a land of make-believe.

It is a land we can enter without leaving the ground of Montmorency, for the buildings in the background of *La Perspective* (The View) represent part of the château there. Several months, perhaps a year or two have gone by, as is indicated by the infinitely more subtle and rich technique. But Crozat's spaniel is still there. The dance has ended. Charming as it was, it was a distraction from the meditations which love invites. Now only music is left, and the dreams exchanged by sweethearts. In this more intent silence, mild solemnity is no longer troubled by any distraction, a new voice is heard calling: the voice of Elsewhere. The subject is no longer the couple in the center of the picture: it is the path, the perspective that slips irresistibly away into the distance. The water that flowed by the banks and bathed the lower branches in *La Conversation* has now receded, and at the foot of now almost ethereal buildings, it throws back an even more ethereal reflection. And the couple, who were dancing in the *Bal champêtre* and talking in *La Conversation*, are now almost gone. The man makes the same gesture as before, inviting her Elsewhere, and since it is now only a dream, she obeys. She does not look at us any longer, but turns her invisible face to him. He no longer implores: with an assured and airy gesture he leads her off. In a moment they will have disappeared into the unknown beyond the frame. His outstretched arm already touches it.

Thus, in three scenes, a change has taken place quickly, like the changing of sets in the theater without lowering the curtain. Before the *Bal champêtre* Watteau was still a spectator; in *La Conversation* be made his entry onto the stage; in *La Perspective* he was caught up in the role dictated by imagination, and he escaped into

dream. The first phase of the love poem unfolds, the phase dedicated to desire—the delicious game of desire, sometimes feverish, sometimes melancholy. Watteau yields to it. He is intoxicated by it all, from the joys of hope to the pains of disappointment.

His universe became more subtle and delicate, for he retained only nuance and quintessence. It is a mirage: the greenery is more nebulous, as light as smoke; the skies are indefinite stretches of color with vaporous cloud; the water exists only as reflection; the women adopt poses more noble yet abandoned, revealing the suppleness of line or the whiteness of the nape. Everything becomes increasingly vague, marvelous, and elusive. In *Le Concert*, for example, the dance is forgotten, and the music of strings and bows enters the heart more deeply. In the background a man bends over and puts his arms round his reluctant companion. In *Les Deux Cousines* (The Two Cousins) a woman puts a nosegay in her bosom with a provocative gesture, while bending her body away from outstretched hands.

Perhaps Watteau preferred the raptness of desire to the disappointments of reality, as he gazed at the shimmering, distant island for which it is so easy to embark—but can one really land there? For him the distant and the evanescent took on a symbolic value both fascinating and haunting. Woman seen from behind and already departing, her face forever unknown, became the subject of *Les Deux Cousines*. In *L'Ile enchantée* Cythera appears beyond the waters, lakes, and sea. Pointed out by the same couple as in *La Perspective*, it is the goal toward which the man beckons his companion. Dusk falls, gestures become more urgent, outstretched arms entwine. But the woman draws back: coy and mocking, she pushes away with one hand. Everywhere figures are seen from behind. The frivolous heads are only fleeting napes, and as the couple goes off the man scarcely turns around. The *Assemblée dans un parc* offers the same interplay of plea and refusal, distant departure and fading dream. The *Embarquement pour l'Ile de Cythère*, completed in August, 1717, is at once the culmination and resolution of his first phase. The long delayed execution of the masterpiece which the Academy required as a reception piece, freed Watteau from an obligation that had been weighing on him for five years. This preoccupation may have contributed to his obsession with the distant and inaccessible, which recurred like the leitmotiv in dreams. Such obscure symbols often correspond to a whole complex of preoccupations. Perhaps some amorous adventures were also involved. At any rate, the fascinating and disappointing mirage seems to have disappeared. The couple seems to have found their boat and set off at last for their long impossible goal.

52. Head of a monk
Black, red and white chalks

Boymans Museum, Rotterdam

Ardor

Toward the end of 1717, only four years before Watteau's death, the second phase, that of eagerness, began. The second *Embarquement* shows clearly the transformation that was taking place as Watteau freed himself from indecision and dream. His poetry at once became less meditative and the "mirage" vanished, leaving a vision that was more positive, possessive, and demanding.

Perhaps *L'Amour paisible* (Peaceful Love) marks the transition. Its vast spaces and enchanting distances belong to the period just ending. The great gnarled tree trunk on the right is the same as in the *Embarquement*. Yet the figures no longer pay any heed to the call of the horizon. The couple seen from behind have forgotten to leave: they are too interested in the other lovers embracing *(Fig. 14)*. The three figures in the center resume their concert in peace. The dog can go to sleep: no one is going away.

Is there a departure even in the second *Embarquement?* The island is no longer there—just some discernible morning mists. But all the material elements are stronger. Reality becomes assured, almost insistent. The brushwork is used to bring out objects and refine local color relationships rather than to create soft all-over harmonies. Plump cupids are everywhere. Trees, leaves, and even the boat fill the space with their dense masses and seem to clog the air. The statue, which before was carcely differentiated from the pedestal, takes the form of Venus and only needs an extra glaze to become a living body. She is the first of the Galateas our new Pygmalion will bring to life and let loose in his parks. The spectator thinks of Rubens' *Offering to Venus* with its sarabands of cupids, so no doubt did Watteau—much more than of too-distant Cytheras. The additions to or modifications of his former themes are astonishingly revealing. The cupid in the earlier picture, shivering under his little cape, fidgeting like a puppy at the feet of the first couple, has been replaced by a sturdier one with a mind of his own, who nudges the lady to help her decide. The whole corner is full: a little farther back a young woman eagerly holds out her apron to catch the armfuls of roses her lover tosses. In front of her, a couple are already happy to break the line of the initial composition, their mass interrupting the general movement toward the boat. The relaxed attitude of the woman and the authoritative pose of the man check the original crescendo which starts hesitantly on the right side of the picture. The arms of Mars, which are in full view at the base of the statue, make it clear that he is Venus' lord and master. On the left, the couples in the boat make haste and draw each other along by the hand. Flowers triumph everywhere, proclaiming full bloom and perfume where once there was scarcely room for hope. The theme, superficially identical to the first *Embarquement*, has in fact changed its meaning and now is one of assurance and success.

The execution has changed accordingly: where before pale colors and nervous accents created an unstable mirage, now the paint is heavily worked, glowing, insistent. Realism is again taking over from dream. Realism had never really disappeared from Watteau's work although, for a time, it was veiled in make-believe. But even while the poet pursued his reverie, the painter sometimes harked back to the tradition of "representation" which Northern art had preserved since the fifteenth century and handed on to him. By nature he was changeable. His friends pointed this out: Gersaint sais that "he had a restless and changeable disposition," and Caylus spoke of "a certain sense of instability that is dominant." Now, modern psychology would say "cyclothymic." Watteau must have striven simultaneously for both the possession of the real and the pursuit of the imaginary. This complexity precludes any too doctrinaire dating of his pictures since some that show signs of having been painted almost at the same time belong to psychologically divergent tendencies. After *Les jaloux* (1712) his brush devoted itself to capturing visible truth and perfecting its own mastery. *L'Amour au théâtre français* (Love in the French Comedy), which belongs to the beginning of the "Crozat period" has a porcelain precision in its juxtaposition of pure color. Its companion piece, *L'Amour au théâtre italien* is an attempt at nocturne in which all is veracity and poetry plays no part. But these are comparatively early pictures: the first still has the feathery poplar of the rustic scenes and, like the *Bal champêtre* from which it developed, there are the vines that Watteau painted almost exclusively at the time of the *Saisons Crozat*. The same dancer as in *Bal champêtre*, only more richly clothed, appears again wiht the same partner in *Les Plaisirs du bal*, where a scintillating realism sets out again toward dream. On the other hand, the brilliant finish of *L'Amour au théâtre français* leads to and culminates in the perfect technical mastery—at once exact, elegant, and subtle—of the *Fêtes vénitiennes*. Here the dancer, whose destiny seems linked with Watteau's experiments in precision, again occupies the center of the scene, like a "counter proof" of *L'Amour au théâtre français*. Now, juste before she vanishes forever from Watteau's painting, she is even more richly adorned.

This current of realist lucidity was always increasing in strength and never ceased, even when Watteau yielded to his longing for make-believe. From the second *Embarquement* on, the imaginary world seems to fade like mists before the rising sun. This was probably the effect of some psychological change in Watteau. Nostalgia, the distant, the imponderable lost their value for him. Fleeting desire gave way to something more definite, more material, a kind of eagenerness. At the same time, his technique ceased to confine itself to suggestion

and took on an insistence that sometimes was almost anguished.

What was taking place at that time in Watteau' life? There is no need to speculate. It can be seen that the change coincides with the appearance of a new model. He had used her, in fact, for the new figures in the second *Embarquement*, which introduce among the more hesitant pilgrims a brighter, more sensual, more Rubenesque note. Identifiable in sketches for paintings, she appears often in a series of studies of nude and half-clothed figures which have a new intimacy. These drawings often include a familiar and modest piece of furniture, a couch, which undoubtedly was in Watteau's apartment. The girl lies on it, propped up on one elbow and wearing a loose dressing gown that leaves her breasts uncovered. In another drawing, the dressing gown is thrown over the back of the couch, while the girl sleeps, half-covered by her shift *(Fig. 7)*. On another occasion, she is taking the shift off *(Fig. 25)*; elsewhere, half-dressed, she is doing something to her ankle, or putting on a stocking *(Fig. 8)*. Sometimes the couch is not there and she stands, busy with something; twice, we see her holding out her apron. She is certainly no lady visitor: her dress, when she has not removed it, is very homely and her hair often falls in negligent wisps. Who is she? The only clue is d'Argenville's phrase: "his servant-maid, who was pretty, acted as his model." So here without a doubt is the only intimate model who appears in Watteau's drawings, perhaps the only nude model he ever used.

The Academy school taught its pupils to draw only from male models since only the male nude was considered worthy of "seriously" interesting the official art of the seventeenth century. Watteau discovered the female body with its more tender and voluptuous curves in the Venetian paintings in Crozat's collection. As has often been noted, his *L'amour désarmé* is taken from a drawing by Veronese. As Herold and Vuaflart have shown, *Diane au bain* (Diana Bathing), was based on an earlier drawing by Watteau of Louis de Boullogne's *Repos de Diane* (Diana Resting) of 1707 *(Fig. 16)*. Watteau saw all these nudes indirectly, through the masters.

Soon after, in the *Saisons Crozat*, Watteau introduced a live model whose figure (with small bosom and slender raised foot) and small sharp-nosed face are recognizable in the sketch for *Le Printemps* (Spring) and in the *Lever* and *Antiope (Fig. 29)*. So it may have been about then, 1715, that the "servant-maid" went to work for Watteau and began to act as his model. One or two years later, after the first *Embarquement* (1717), she seemed to have assumed a much greater importance, and then brought into his work a type of woman, less mysterious but more sensual and more abandoned than before.

More precise gestures and embraces became frequent, such as one figure taking another in his arms. This attitude, discreetly hinted at in the *Danse paysanne* (Country Dance), is taken up again in *L'Amour paisible*,

53. Study of a man's head in red and black chalks
Private collection

where it becomes bolder in reaction to the woman's halfhearted defense. In *Le Faux pas* it becomes the actual subject, while in *La Surprise* the man attacks and wins a willing kiss under the eyes of Mezzetin. For such triumphant ardor the ordinarily less bold Watteau referred to Rubens' *Kermesse*, which shows how far he had come: What strange transformation could he have been going through?

The usually refined Watteau even surprises us with the extremely Flemish verve of *L'Indiscret*, although he does give it a popular setting. The era of shy desires, distressing hopes, and regrets is over. Whether it was a sign of maturity or of the inroads of tuberculosis, which often stimulates sensuality, Watteau was no longer an adolescent dreamer. He was beginning to feel at home in life, and love, which before had been only a gentle attempt, now entered into its fullness. Never had Watteau been so close to his elder, spiritual, brother Rubens. Like him he was now dazzled by childhood: he could not do without it and put its games and little round bodies everywhere. Unlike Rubens, he did not use fruit as a swelling image of life but he scattered roses, lighter and fragrant, everywhere.

Had he stopped dreaming, then? To say this would be to misunderstand him: he never ceased to maintain, side-by-side, the dual currents of reality and dream, although they took turns in dominating. Now, reality ruled. On the other hand, never had music reigned so universally in his work. Music would enable the life of the spirit to counterbalance the new force of physical realities. In *L'Indiscret* and *La Surprise* it counteracts the sensuality *(Fig. 3)*. Apart from an occasional Pierrot or woman playing, music in Watteau's painting had for a long time been primarily an accompaniment to dancing, an occupation for and bond between lovers. At first his young people used music as an amusement, but then as they became more thoughtful and langourous, desire chose shadow and silence as its companions.

Concerts do not appear until late. The first is in the picture at Potsdam actually called *Le Concert*, and is swathed in the drifting mists of distant shores. Another appears in *Les Charmes de la vie*, in an architectural setting which, like that in the earlier *Les Plaisirs du Bal*, recalls the classical influence of Italy. The concert stands out more a little later in *La Leçon de musique*. With each successive concert, the precision and intensity of technique grew. *La Leçon de musique* formulated the dominant theme of these years, 1718-1720: a couple organized in relation to music, living and communicating through it. Whether it is *La Game d'Amour* (The Scale of Love), *L'Accord parfait* (The Common Chord) or *Le Concert*, the man plays an instrument and the woman follows the score, no doubt humming the tune. Sometimes, as in *La Lorgneuse* (The Ogler), there is a pause in the music and the couple exchange a glance *(Fig. 47)*.

Another note is now introduced: one so particular that it enables us to date the works of this period with

certainty. It is somewhat harsh, tense, almost feverish. Was this paroxysm caused by the same disease that kindled Watteau's avidity for life? It is impossible to deny the appearance of a morbid element. The faces have lost their tender youthful freshness. First, the men: in the *Fêtes vénitiennes* we see the beginnings of an excessive characterization of the faces; the bones have become exaggerated, the nose thin, the eyes hollow, and youth visibly withers; at the same time, the hands grow as thin and restless as antennæ.

It is very revealing to compare *Les Bergers (Fig. 19)* with the earlier *Plaisir pastoral:* now all the hands have acquired an extraordinary intensity, whether they reach toward the swing or fend off the disrespectful hunter; whether they are those of the hunter himself, holding his gun, of the dancer in the air, or of the hurdy-gurdy player on his instrument. And the branches and roots that intertwine like tentacles, strangely echo the hands giving an effect completely absent from the same subject as treated several years before. Precisely the same effect can be seen in the second *Embarquement*, *Le Faux pas*, and the *Amusements champêtres*. The hazy leafage of the early pictures is now far away.

The malaise increased with the second *Embarquement*. And in the concerts the women's faces lost their roundness and became slightly twisted. This hidden disjointedness even penetrates the composition: in *La Game d'Amour* and the *Amusements champêtres* the ground tilts, the forms and groups are crooked, and the old feeling of stability is absent *(Fig. 6)*. In this phase, hands, symbols of grasping, take on a haunting, obsessive importance. Playing musical instruments, they are exaggeratedly tense, with long bony joints and tiny red dots that glaringly emphasize the articulation. Each finger is convulsed and distorted into a life of its own. Too red, too splayed out, too harsh, too insistent, they make one think of animals' claws. How strange Sirois' hands are in *Les Habits sont italiens*. Where are the little impersonal hands of long ago? It might be said that this change was all in the cause of observing the musician closely. But the same hands are everywhere, even in the woman sewing in *L'Occupation selon l'âge*. In the *Fêtes vénitiennes* they snatch at the frightened girl; in *Le Conteur* they seize hold of a breast.

An involuntary expressive power, which animates all the elements of pictures of a given period, thus manifests itself. The unconscious coordination of these elements produces "manner", and gives each manner its character and psychological significance. Watteau had reached the point where ardor, or avidity, and strain crept in everywhere, betraying an inner crisis that found its highest poetic expression in *Le Mezzetin (Fig. 2)*. No one, however hostile to subjective interpretation, could deny the poignancy and pathos of his song, at once intoxicating and heartrending. His face may be too defined, his hands too convulsive, but his bent head, open mouth, and distant gaze impart to this ardor a sense of sorrowful supplication. To see what anguish

existed in the apparent brilliance of that period, one has only to look at a drawing in the museum at Rennes of a young man like Mezzetin *(Fig. 24)*. With a strangely gaunt body, long thin legs, huge hands and an unforgettable youthful face ravaged by consumption, he tunes his violin. Such was Watteau then, straining the strings of his art until it cried out, until it broke.

Watteau's art had arrived at a point of tension where its equilibrium was threatened. It seemed as if his realism was becoming stronger. The increased physical presence of his characters suggested that the real was gaining over the immaterial. Flesh and bones encroached more and more upon the air, once so vast and important and full of poetic vagueness. But seen more closely, this concrete assurance expands only to hide the void which space has become now that it no longer contains the elusive. In *Le Faux pas* and *La Surprise*, the compositions had already fallen apart, revealing unusual open spaces; and in *La Game d'Amour* and *Amusements champêtres*, the compositions are strangely unstable. There followed a group of very interesting paintings that define the danger and try to remedy it. On the one hand, against a sky empty because the imponderable has disappeared, Watteau amplified his figures. On the other hand, to balance this emptiness he reaffirmed the importance of horizontals and verticals, as in *Le Mezzetin*. *La Leçon d'Amour* is a masterpiece that covers up any gaps. The sharply characterized hands and face of the man; the same type of woman as the "servant-maid", the twisted roots, the rose, and the lifelike statue, all date the picture unmistakably. The musician, as elsewhere, the actual theme of the picture, is a revival of the early *Enchanteur*, though much stouter and heavier.

We can see Watteau's new "positivism" developing. Although the same elements appear in *La Leçon de chant* (The Singing Lesson) and the *Amoureux timide* (The Bashful Lover) their threatening weaknesses have not been hidden. (The authenticity of these two pictures might be suspect, but for *La Boudeuse* we have Jullienne's guarantee. Here, the vacuousness of the sky has become unbearable, and the stabilization of vertical and horizontal, mechanical.) The position of the couple in *La Leçon de chant* is awkward and unnatural. The *Concert champêtre*, which repeats the man with the roses from the *Amoureux timide*, is also disturbing: it belongs to the same group and seems to refer to the same crisis. The conclusion of this crisis was shown in *L'Amour paisible*, engraved by B. Baron, where the figures' gestures against the sky, the division of the space into verticals and horizontals, and the taste for infancy and roses all lead to an appeasement, a recovered equilibrium. We know that this picture belonged to Dr. Richard Mead, Watteau's protector in London. Thus we come to 1720 and the fateful visit to England.

54. Forest scene in red chalk
 Ashmolean Museum, Oxford

A Regrouping of Forces

As Watteau's career approached its end, a homogeneous group of works offered a summing up of his discoveries and conquests. Did his recent efforts to end the crisis with which he had been struggling lead to this peaceful recapitulation? Or did the oversimplified reaction of a foreign public to his work make him seek a stronger continuity with the past? Or, like one who senses the approach of death, did he recapture the whole of his life in one ultimate synthesis? Whatever the explanation, here we have the whole of Watteau in all his complexity and diversity.

Universal and comprehensive as they are, these paintings do contain signs from which it is possible to date them. The physical type of the "servant-maid" reigns unchallenged. The quest for emphatic horizontals is met with great stone benches, sometimes reinforced by a step that runs parallel across the picture to meet the plinth of a statue on the right. The recently developed motifs of childhood and roses now reach their apogee.

Finally, there is color. The shadowy, variegated shimmerings of the early days had given way to the bright, clear marquetry of *L'Amour au théâtre français*. But the dark harmonies of the period of the *Contrat de mariage* had emerged again in the autumn reveries and sumptuous distances of the *Assemblée dans un parc* and the *Ile enchantée*. Again Watteau struggled with his duality: realistic studies provided interlacings of fresh colors and dreams produced rich dim chiaroscuro. Both registers came to him so spontaneously: the first and more poetic *Embarquement* is bathed in an overall harmony with scarcely a red to disturb it; while the second, which is painted with such realistic virtuosity that it is almost defiant, is broken up into a complex interplay of different flashes of color.

It is as if Watteau wanted to conjure up all the conquests of his last years and adorn them with ultimate splendor. Themes are brought together again: the servant holding out her apron, the same servant picking roses, the woman raising her black veil. The warm, round body of the servant can be seen in the statues: *Antiope* reappears in the *Champs-Elysées* (The Elysian Fields), the Venus of the second *Embarquement* in *La Fête d'amour*, the seated nymph of *La Leçon d'Amour* in the *Divertissements champêtres (Fig. 13)*. In the *Réunion champêtre (Réunion en plein air)* she takes a new pose and presents her round hips to Wleughels' willing inspection. Wleughels himself is straight from the *Fêtes vénitiennes*. The group of children with a goat, a memory of Crozat, are revided in the *Assemblée dans un parc*. Here again Watteau juxtaposes Wleughels, showing off worse than ever with the couple from the *Game d'Amour* and the kneeling lover

grasping at the lady's breat from *Le Conteur*. The guitarist of *La Surprise* also plays in the *Réunion champêtre*. The same group that formed the background in *Le Concert* now forms the foreground in the *Fête d'Amour*, as they point out the couple that had appeared in *Le Faux pas*. Around them all is the poetry of roses in profusion, water trickling from fountains, children at play. The universe of Watteau is at its apotheosis; the theater of his imagination presents the grand finale of its accumulated riches.

As we enter the phase in which all of Watteau's poetry will be gathered together in one last bouquet, we see that each picture is draped in autumnal symphonies of russet and bronze. The final return to realism, of which *L'Enseigne de Gersaint* is the supreme and perfect example, will be marked by a more refined version of the brightly lit, variegated colors already used so successfully in the *Fêtes vénitiennes*. But for the moment Watteau reassembled the imaginary universe of his dreams and revived the great parks of the fall of the year, fading in reds and golds. Probably the lush greenery of England suggested a nature more lyrical than ever, where endless shade obscures the figures.

And the couple? Would the disappearing couple, with their melancholy happiness, return? They do, providing the central motif in Dr. Mead's picture of *L'Amour paisible*, and slipping into the background of the *Réunion champêtre*. (The *Fête d'amour* brings them closer and turns them around. The *Assemblée dans un parc* puts them in front of us, leaning with curiosity toward two other lovers.) Nor has Watteau forgotten the theme of departure, which was once his only theme but which has now lost its mystery. He no longer has the instinct for making his compositions meander upward, toward the horizon, and to the left toward the past. The sinuous farandole is restrained by the rigid stone horizontal. In only one or two paintings of this periods does the curve of the trees sometimes join the foreground with the middle area. Rather, the composition formed by the figures rises up diagonally to the right, as in Rubens. The subtle ebb once found in inspiration is lost. The whole picture takes on an assurance, a stability, and a more optimistic movement, all of which counteract the distances now once again revealed, the autumnal mood, the forest depths, and the harmonies of rust and orange, black and violet. The tinge of melancholy fades, and mingles with a more peaceful atmosphere.

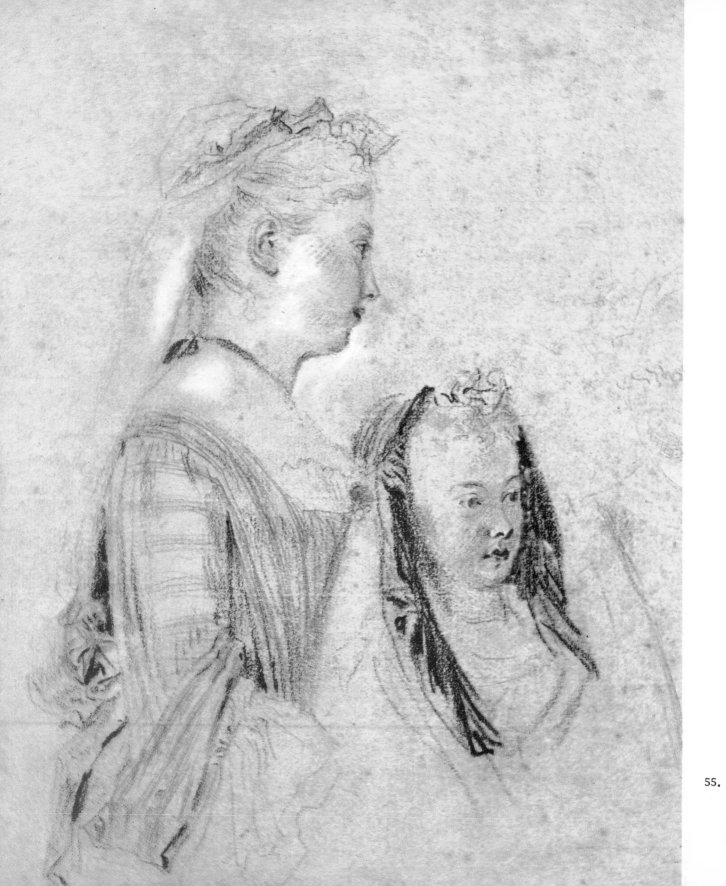

55. Study in black,
red and white chalks

British Museum,
London

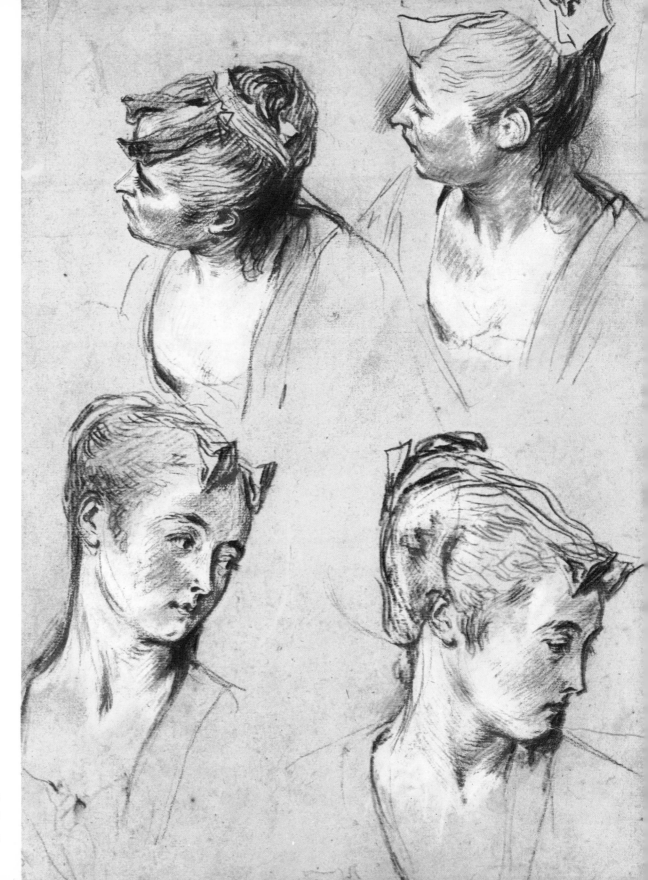

56. Study of heads
Red, black and white chalks

British Museum, London

Acceptance of Reality

The *Le Retour de Chasse*, which was presented to Jullienne at the time of his marriage late in 1720, concludes this last phase. In it Watteau's various tendencies still mingle and echo. The motif of figures arranged in a row toward the left background replaces the recent line leading to the right. Horses, reminiscent of his youth and borrowed from a military scene, *Départ de Garnison* (The Departure of the Garrison), acquire a striking realism. The gnarled and twisted roots and branches of the previous phase of ardor become the dense, rich foliage of fulfillment. Watteau's art, in spite of certain deficiencies of execution due to his undermined health, demonstrates that he is now mature, that he has reached the age of certainty and fact. And love? He no longer thinks of it. He exists, peacefully. Calm conversations suffice; music itself is now silent. Does all this indicate happiness and possession? Yet how threatened it was! When the crisis that preceded his visit to London was over, Watteau unsuspecting, leaned more and more upon reality. It was as if his unconscious "retrospective" had finally liberated him from his daydreams. In his last works he is, above all, positive.

Then poetry blends definitively with reality. *Iris*, or *La Danse*, is a straightforward echo of Mathieu Le Nain's *Dance Lesson*. The little girl of the earlier paintings has grown up and tries out her young-womanly charms. Watteau had an almost paternal tenderness for the attractiveness that graces the end of childhood. The village steeple on the right, from the long-forgotten *Montreur de marmotte*, is the only reminder of his own youth. He returns also to the theater and his beloved Italian players. Here again mirage and illusion have fled: what he paints are groups of real actors. Sometimes they are in the country, laughing at a dog chasing ducks *(Les Canards)*. There is no more talk of love. Yet Pierrot is there, with his friend in the lace cap who is also seen in *Gilles*. Pierrot appears again in the center of the *Comédiens italiens*. All is order, truth, and logic. Here the horizontal is indicated by the steps in the foreground that parallel the frame, a development of the method used in the previous phase. The central axis, not displaced this time, is provided by Pierrot and confirmed by the regularity of the architecture, including the door at the back, and by the figures grouped around it so as to form a pyramid. The companion piece, the *Comédiens français*, also uses an architectural setting, but slightly less symmetrically. The main character, with his feathers and fine clothes, occupies the middle, and the two archways and three central figures echo and balance one another.

But what has become of poetry? Poetry makes a supreme comeback in the two masterpieces, *Gilles* and *L'Enseigne de Gersaint*. The first still contains a glimpse of Watteau's early work in the feathery poplar and

umbrella pine. Everything is absorbed into the equilibrium of the large central figure, into the assurance imparted by the life-size proportions, into the ever increasing power of positive presence. *L'Enseigne* also acquired all the weight of evidence. The horizontal of the pavement accentuated by the pattern of the cobbles; the door in the middle out by the central axis; the frontal perspective—all speak only of order and rectitude. Where is love? Where is dream? Watteau has conquered reality and certainty at the moment when life is ebbing; miraculously he is still master of the brush.

Here the career of Watteau ends.

But no. It opens up on new and unexpected destinies. What is left to us of Watteau? His youth and the dreams of his youth had flown. The Watteau who approached his forties and the fullness of his powers with new assurance was preparing a different concept of the world and of his art.

We take the facts as they are—a life cut short by chance—and naively assume that his death corresponds to the profound decree of destiny. We think that destiny was fulfilled, merely because his life was halted, shattered in full flight by disease just when he had ended the "episode" of his adolescence and was about to develop the vision of his maturity. What would have been the future of the fact that followed fiction, of the presence that succeeded mirage, of the search for the real that replaced the flight into dream? What would have become of Watteau himself—and of the eighteenth century which, because of his premature death, was nourished by his youth alone? An entire part of his genius remains forever unknown. He remains the teasing enigma of his century, as Géricault would be of the next.

The mystery of Watteau is not in his work. It lies, like a question, over all he left undone, all for which he did not have time.

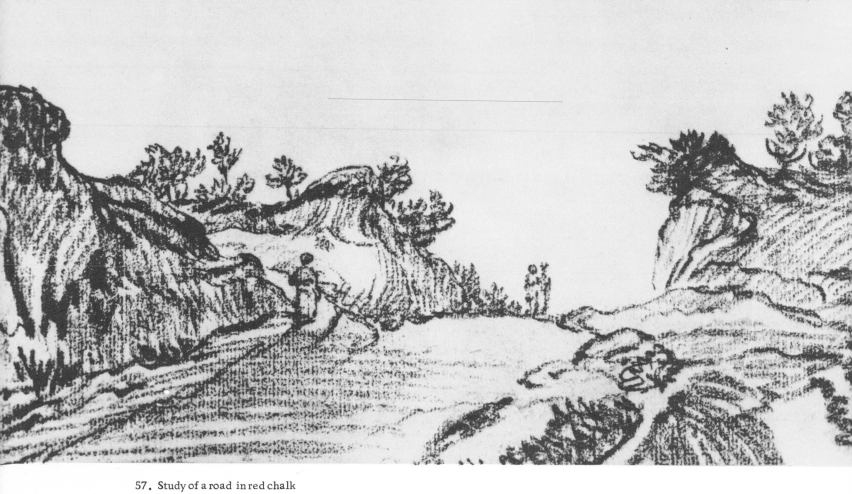

57. Study of a road in red chalk
Private collection

58. Study of Crispin in red chalk
Pushkin Museum, Moscow